MENAGERIE

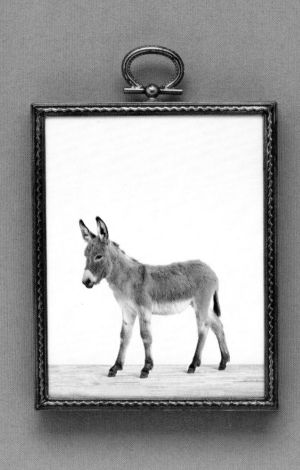

MENAGERIE

SHARON MONTROSE

ILLUSTRATION ᴀɴᴅ LETTERING ʙʏ JULIANNA SWANEY

AN *IMPRINT OF*
HARPERCOLLINS*PUBLISHERS*

I think I could turn and live with animals, they are so pl

d self-contained, I stand and look at them long and long.

—WALT WHITMAN

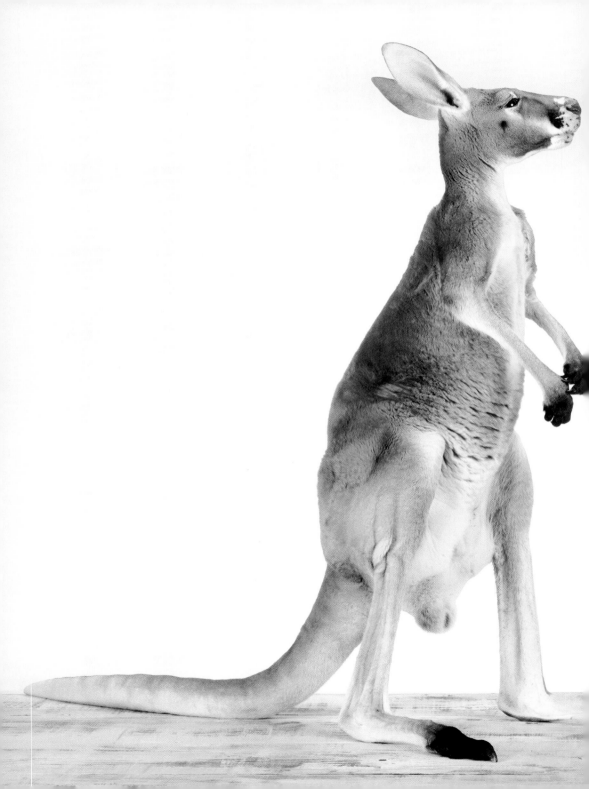

Contents

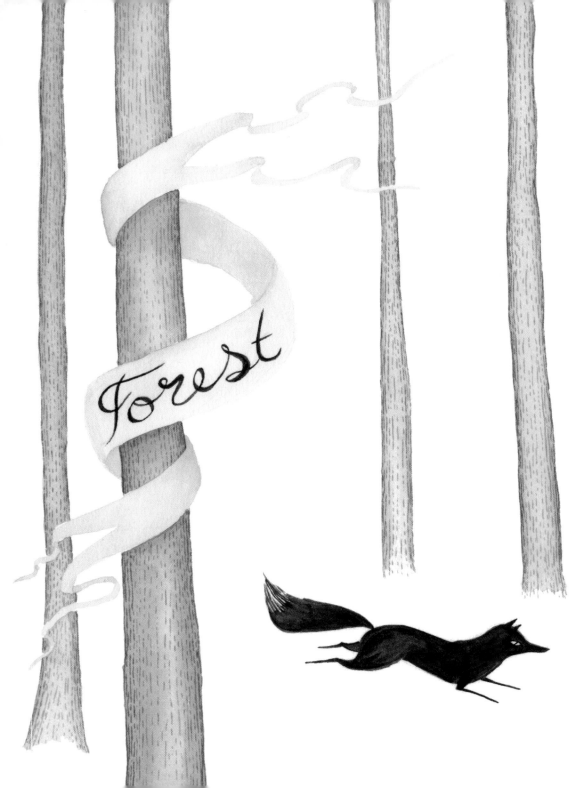

Forest

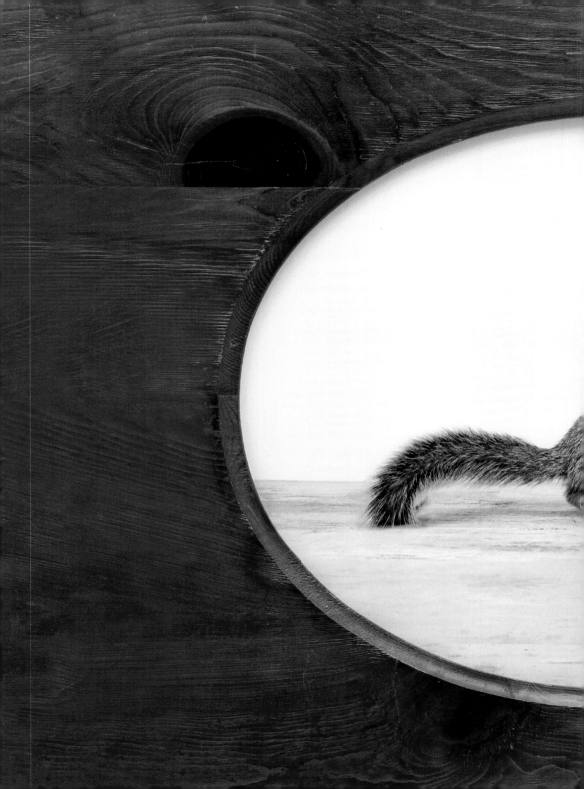

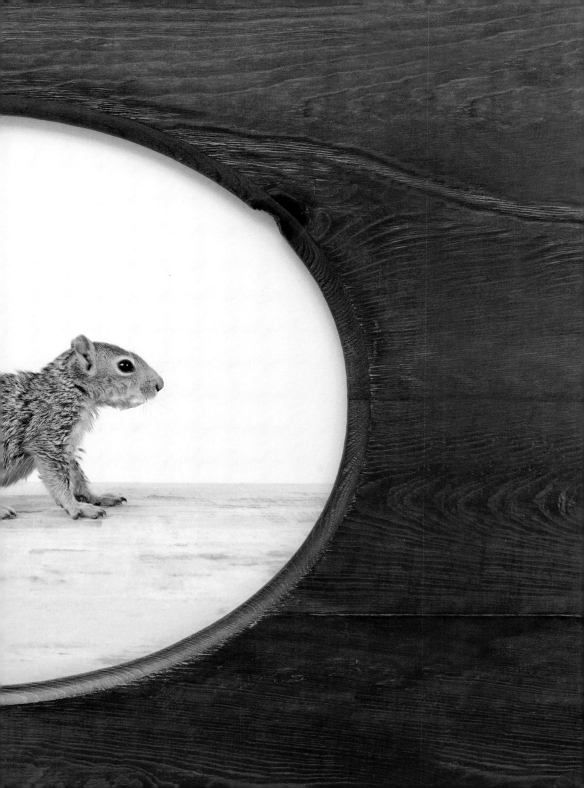

SOMEWHERE

There's

SOMEONE FOR ME

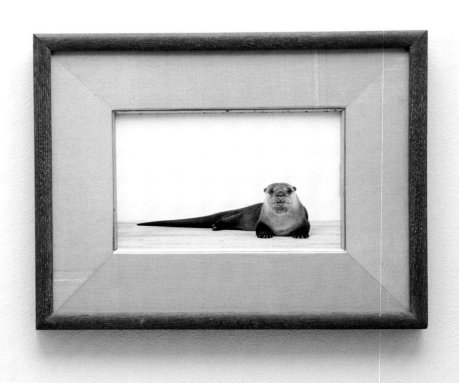

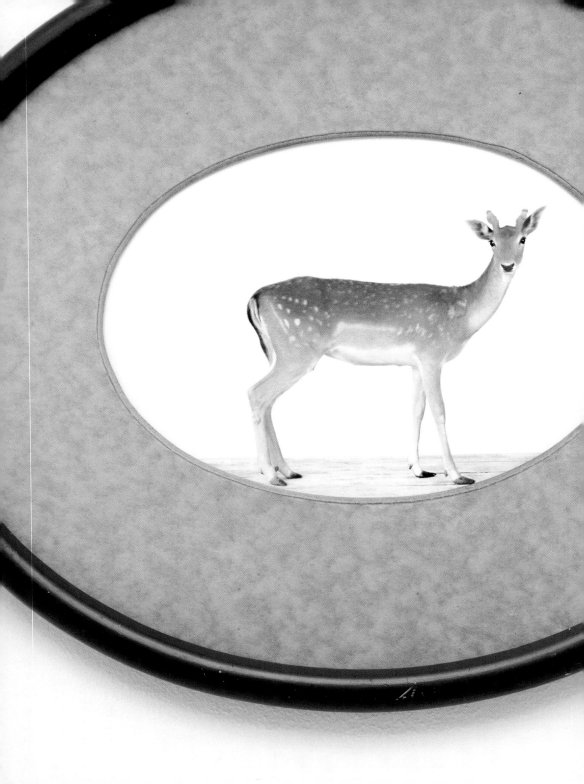

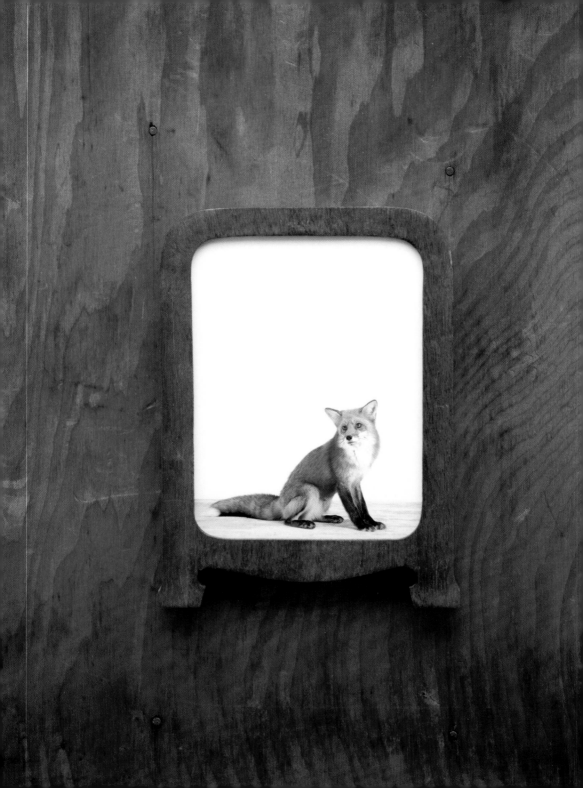

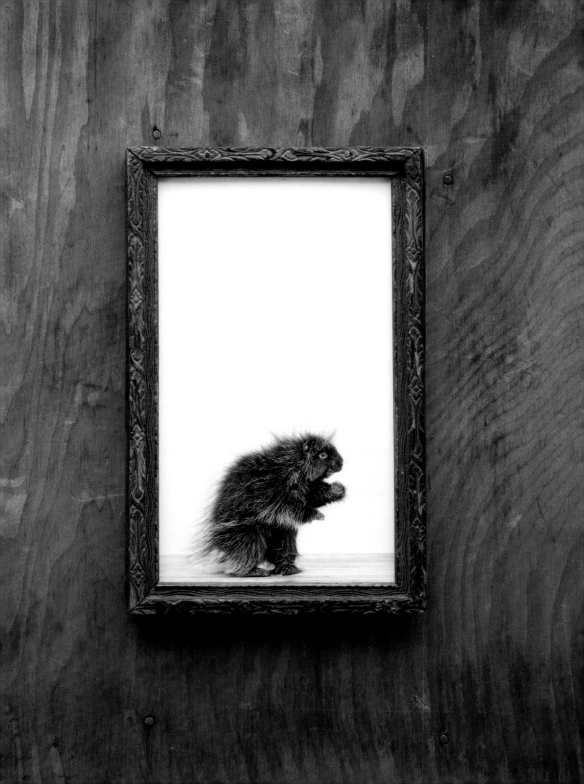

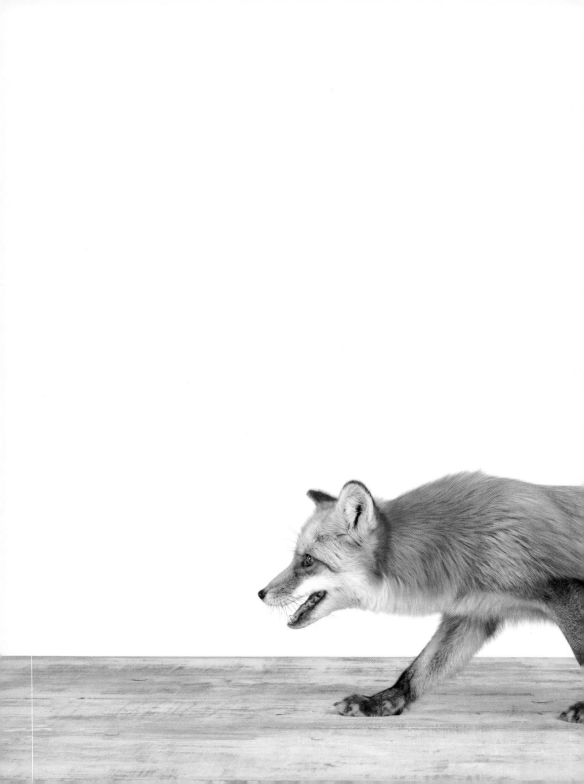

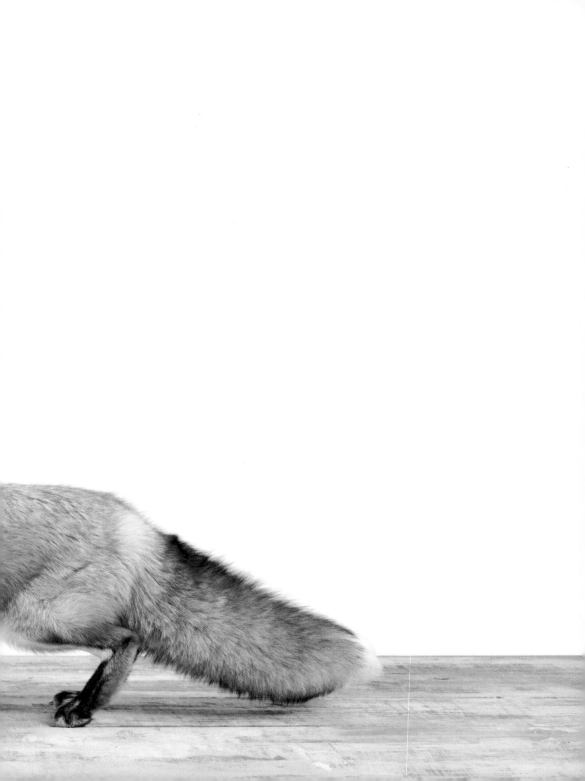

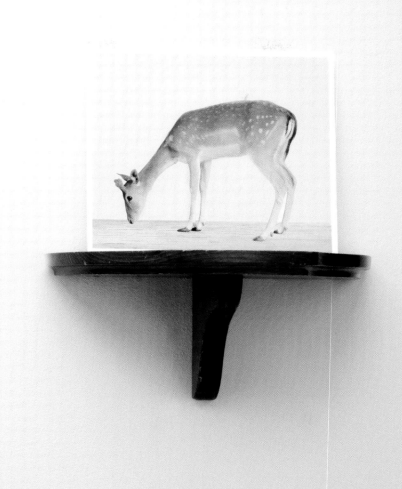

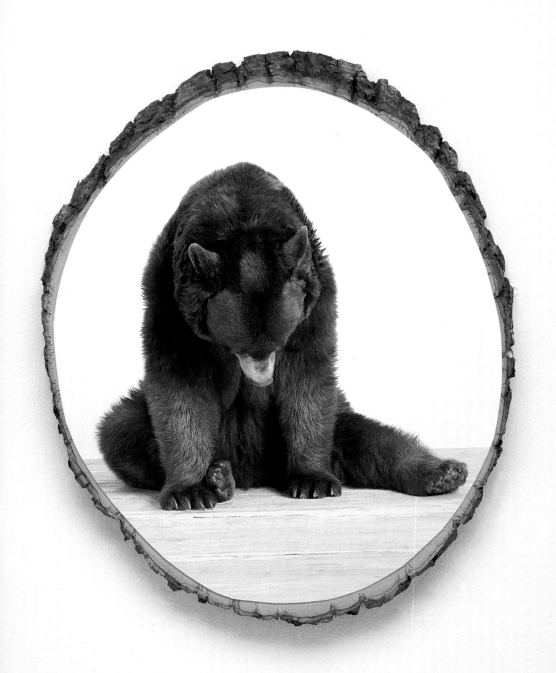

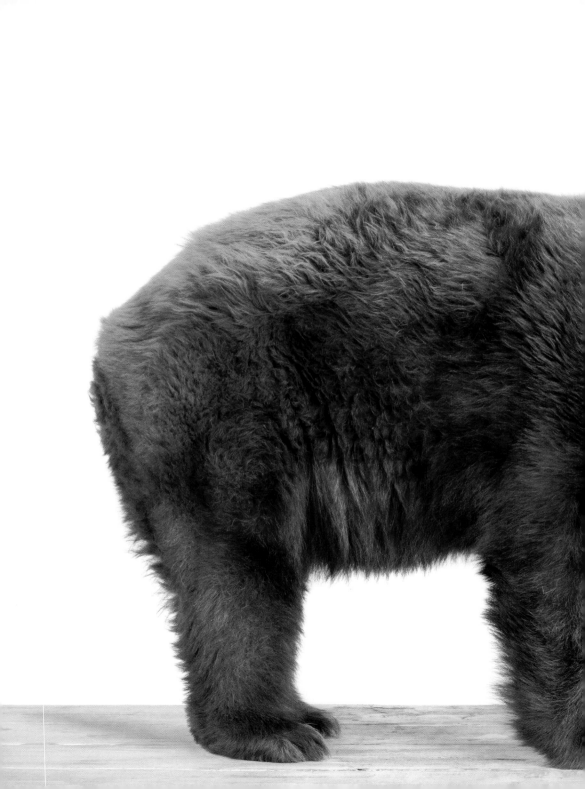

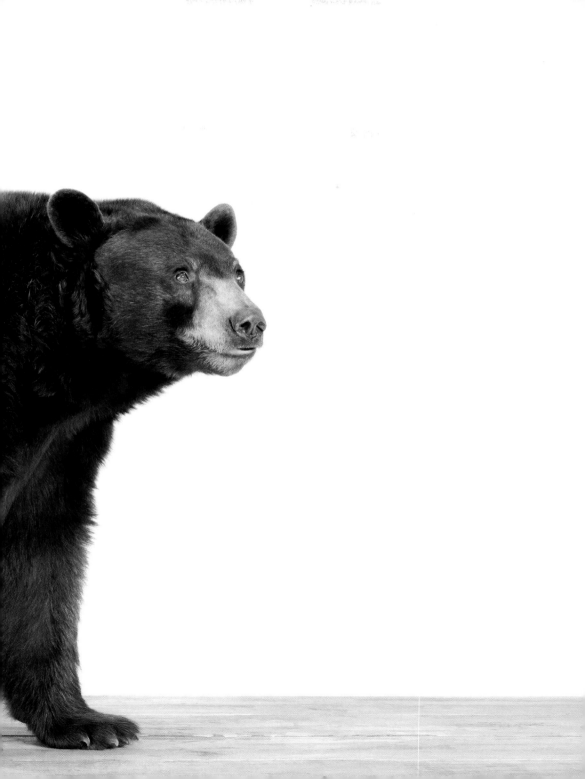

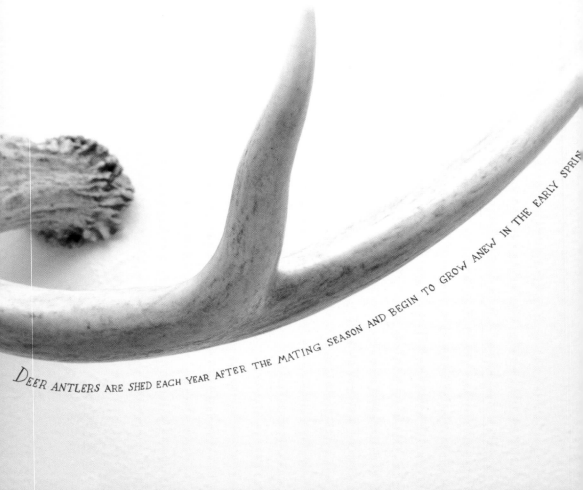

DEER ANTLERS ARE SHED EACH YEAR AFTER THE MATING SEASON AND BEGIN TO GROW ANEW IN THE EARLY SPRIN

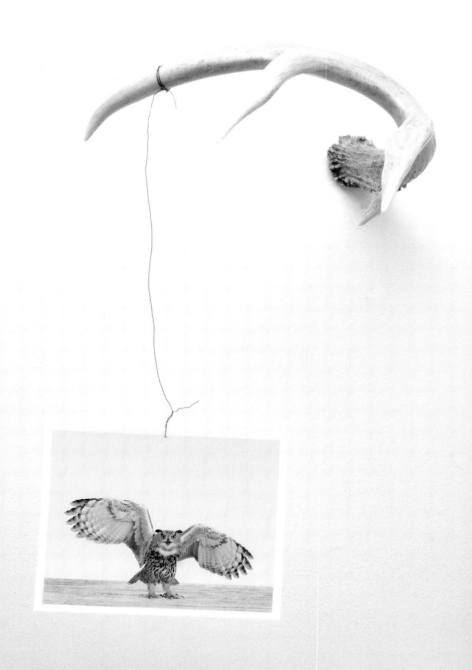

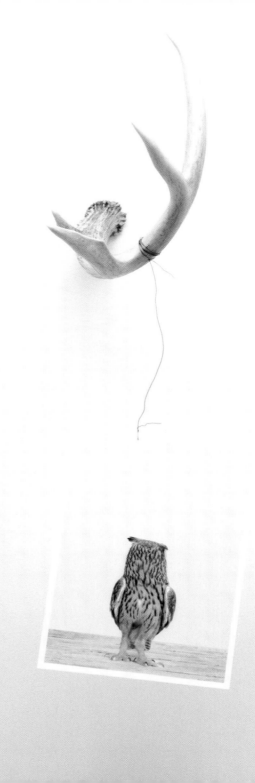

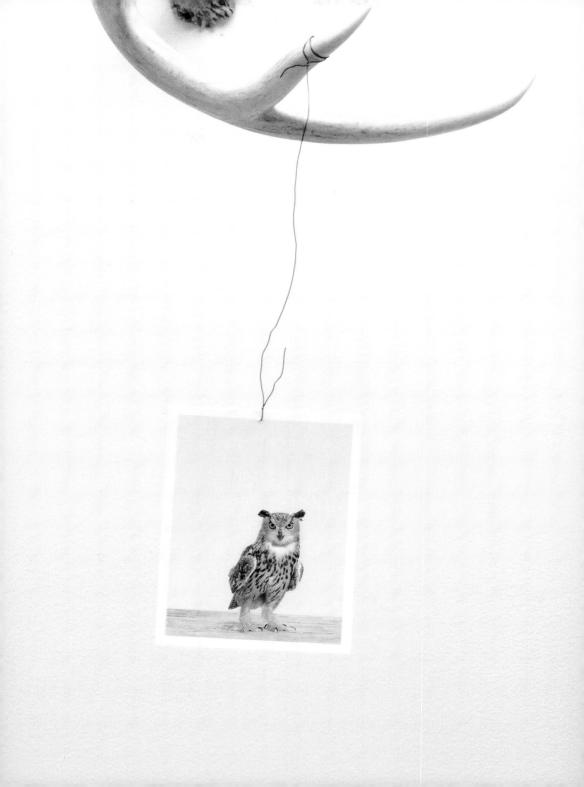

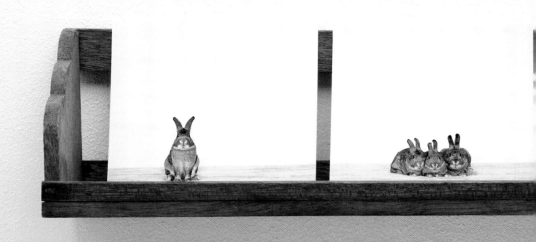

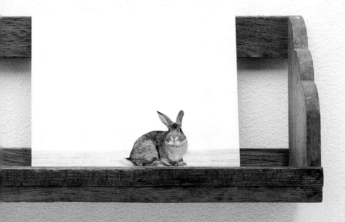

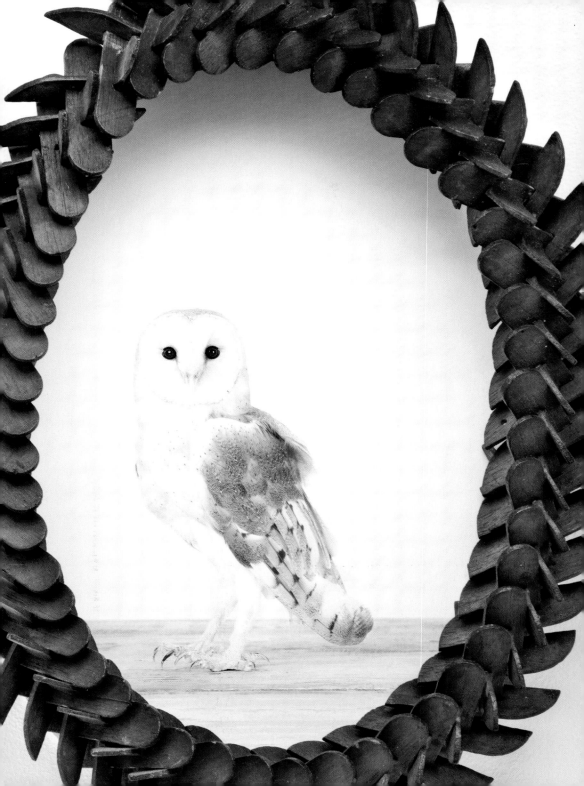

BABIES

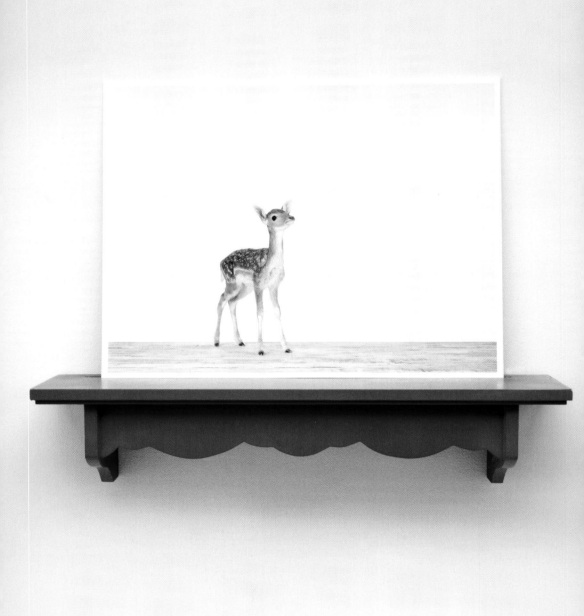

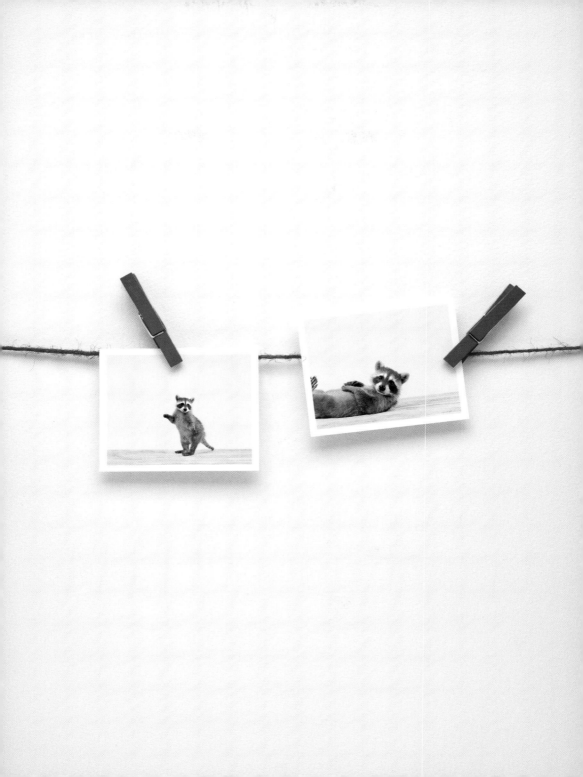

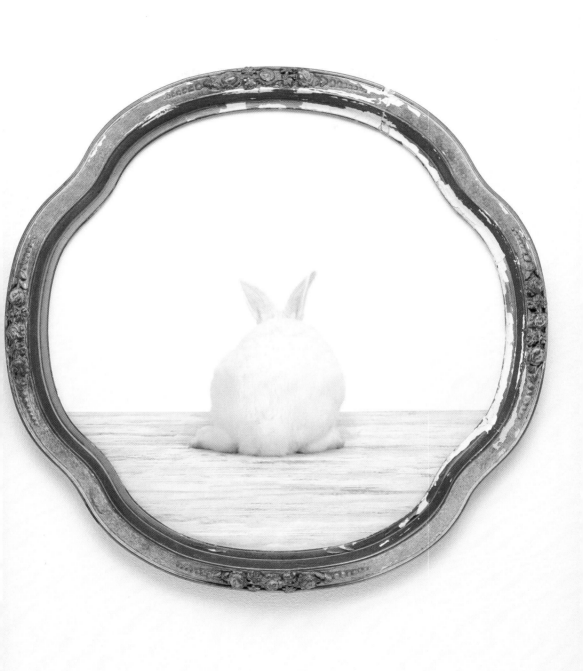

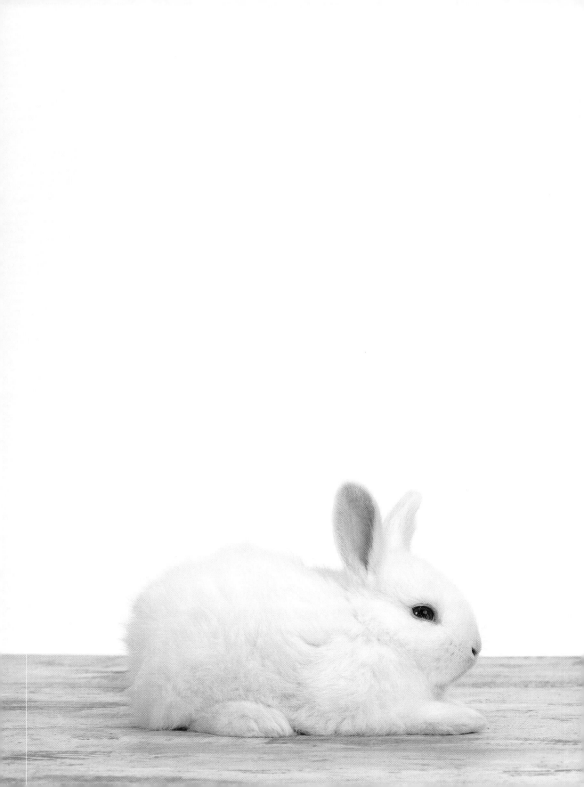

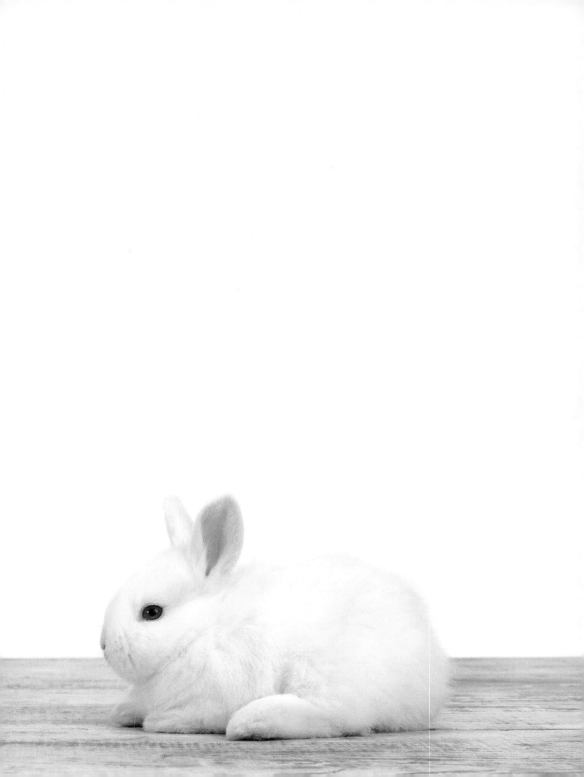

put your
HEAD
in the
clouds

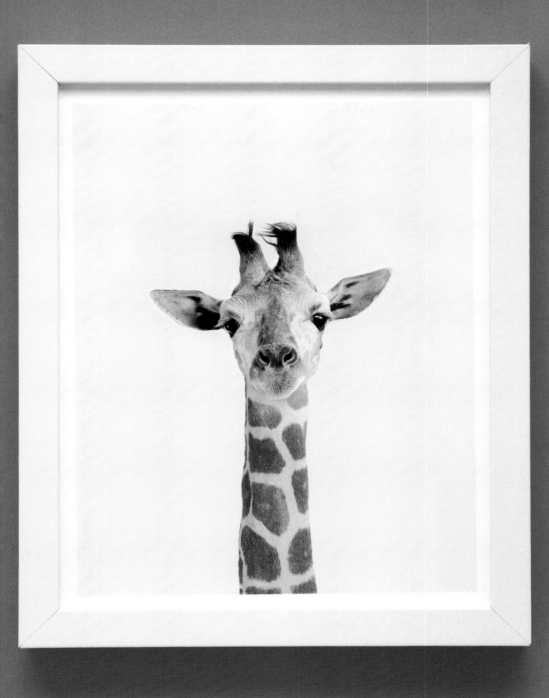

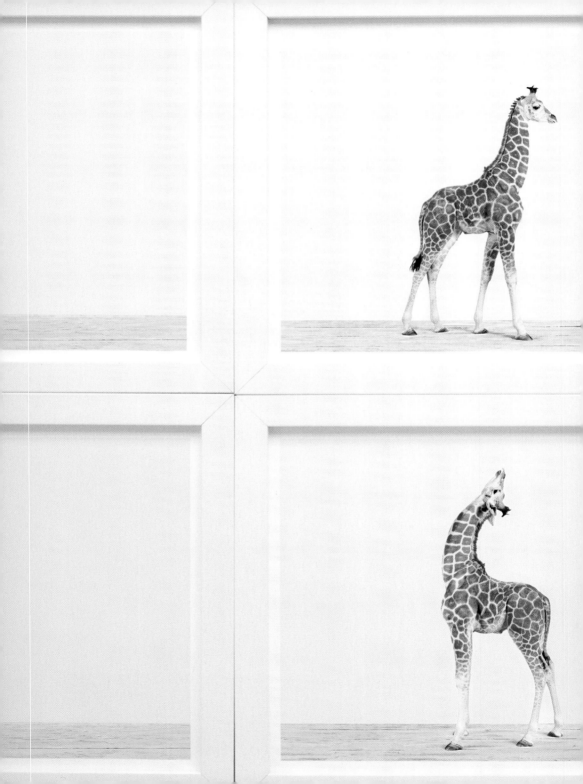

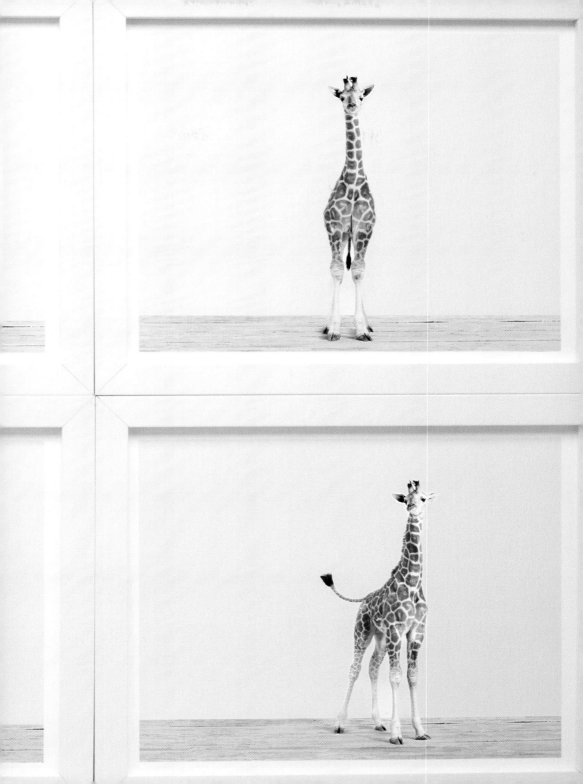

Little Darlings

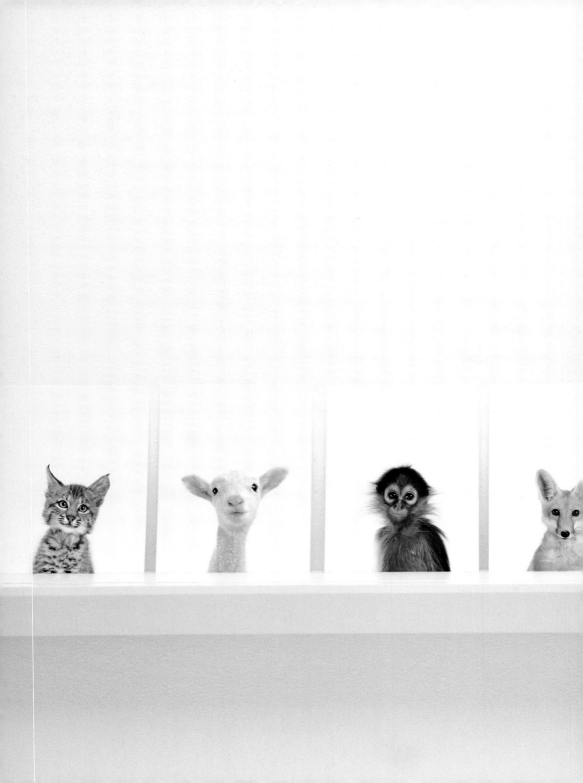

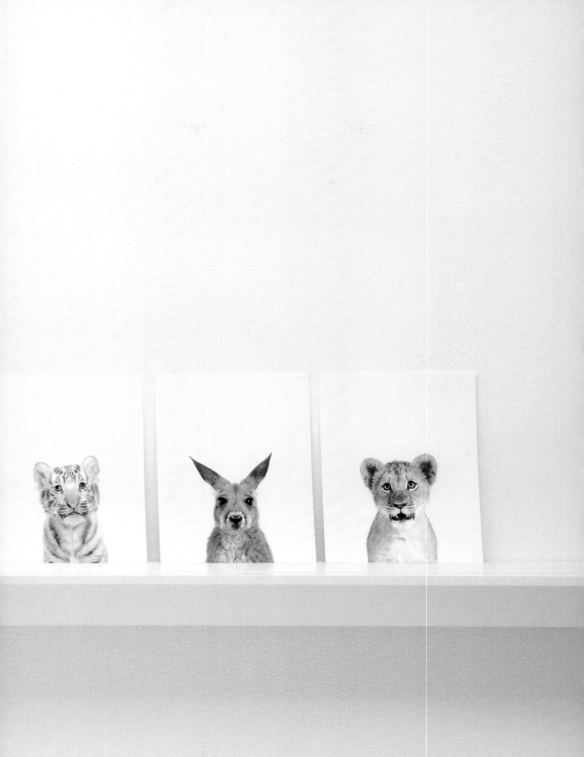

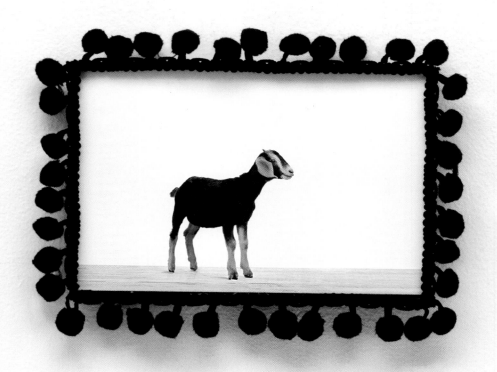

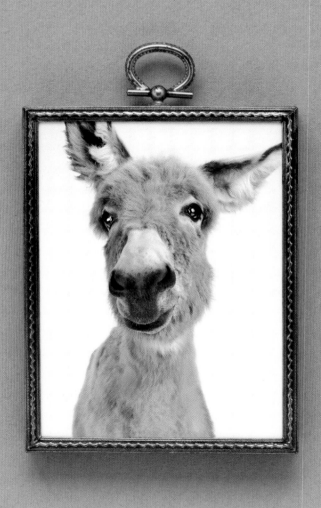

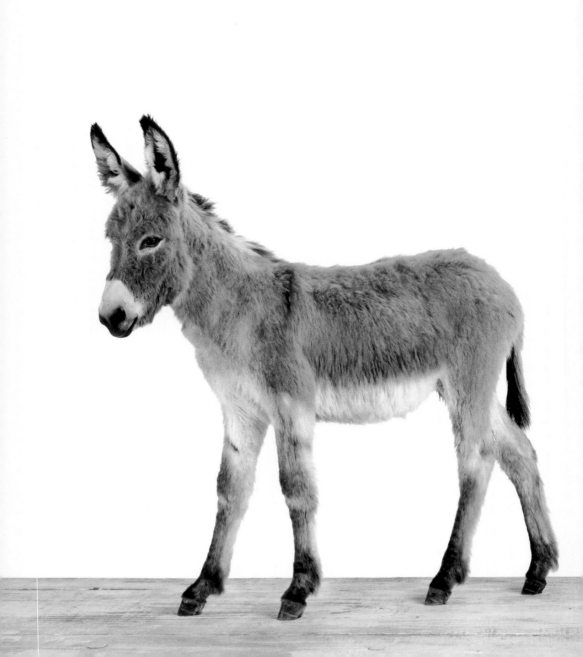

The Fox & The Hound

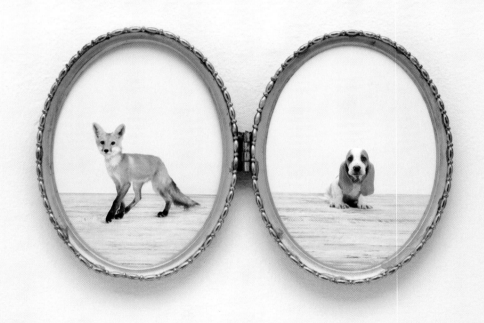

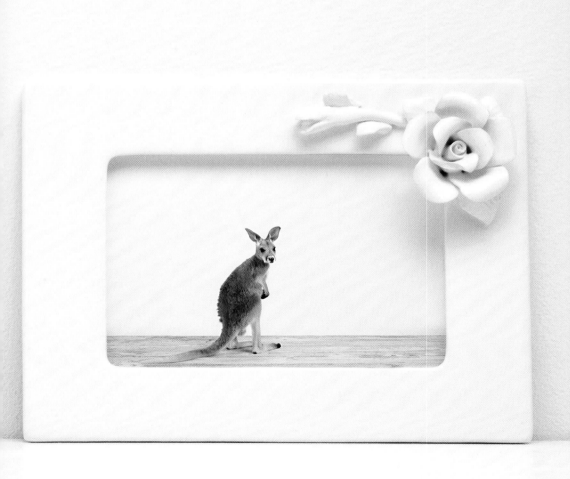

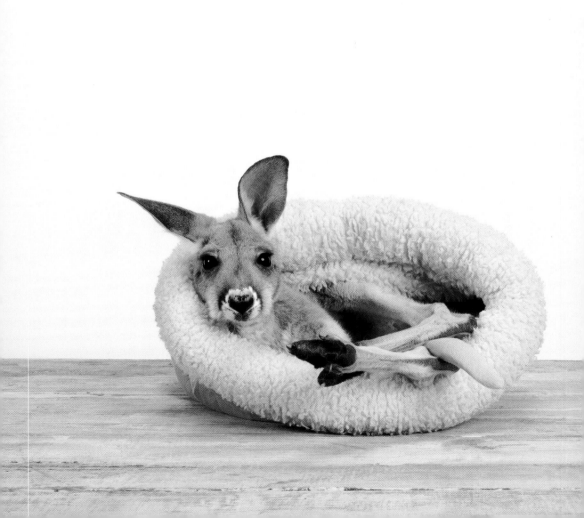

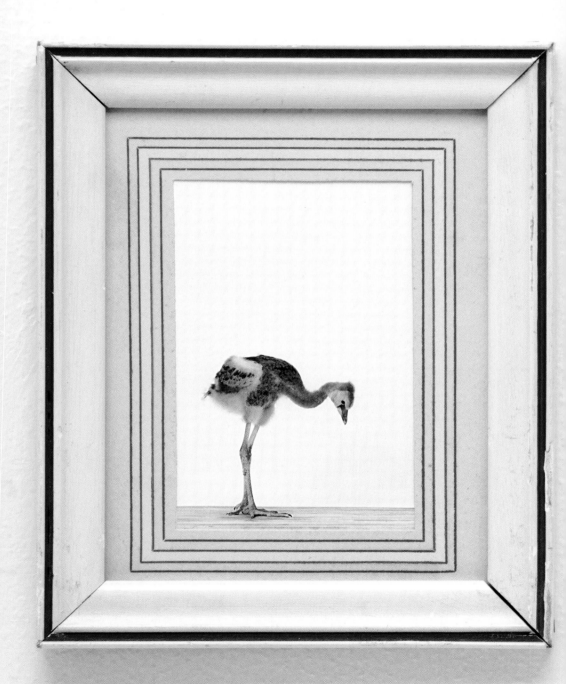

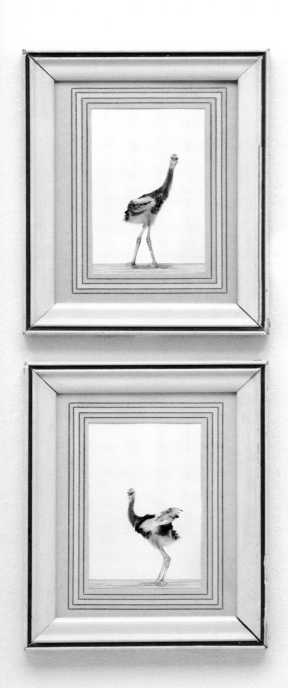

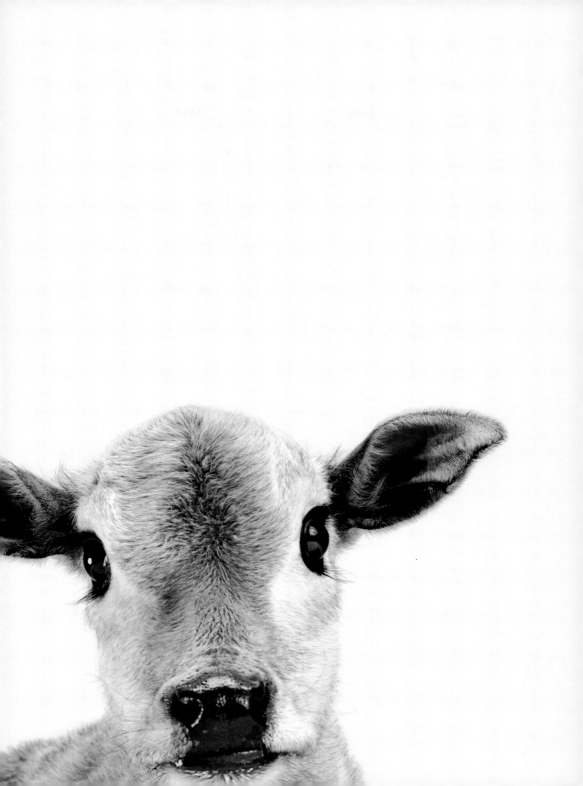

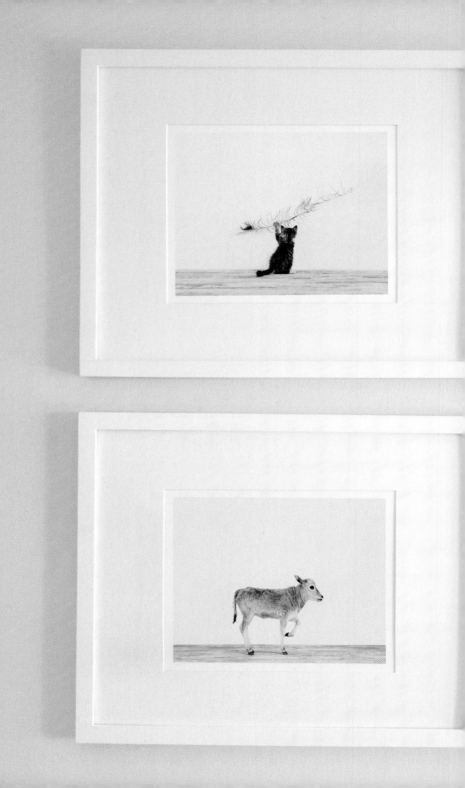

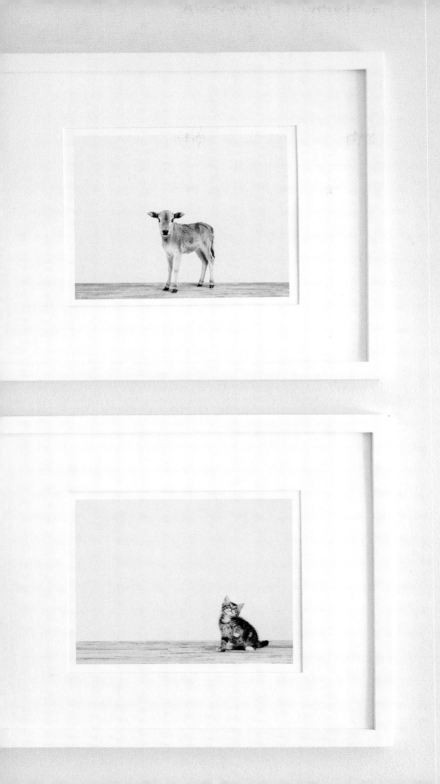

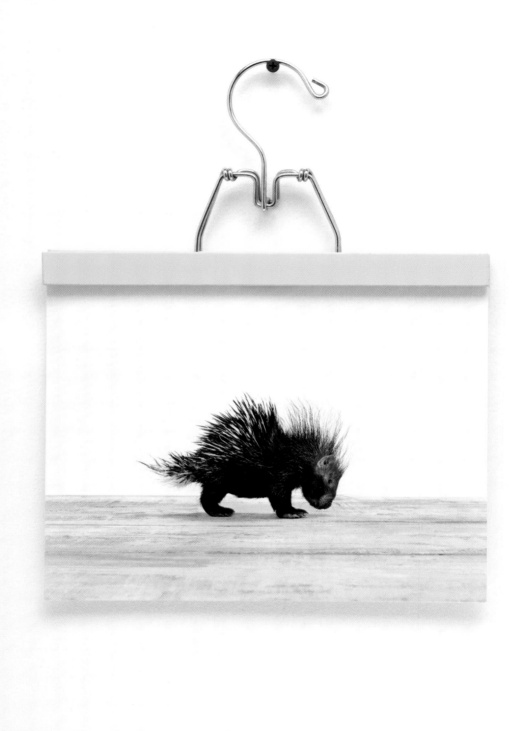

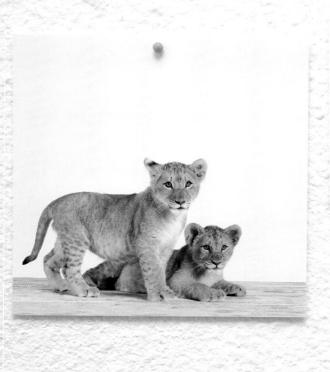
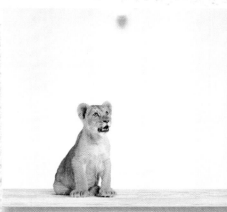
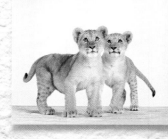
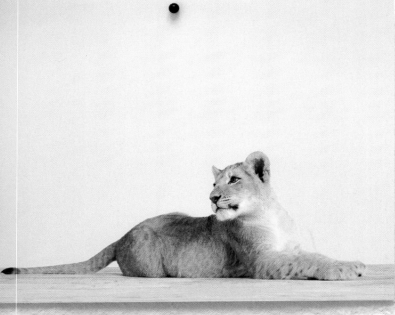
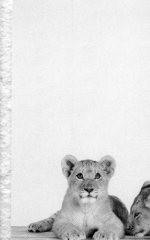

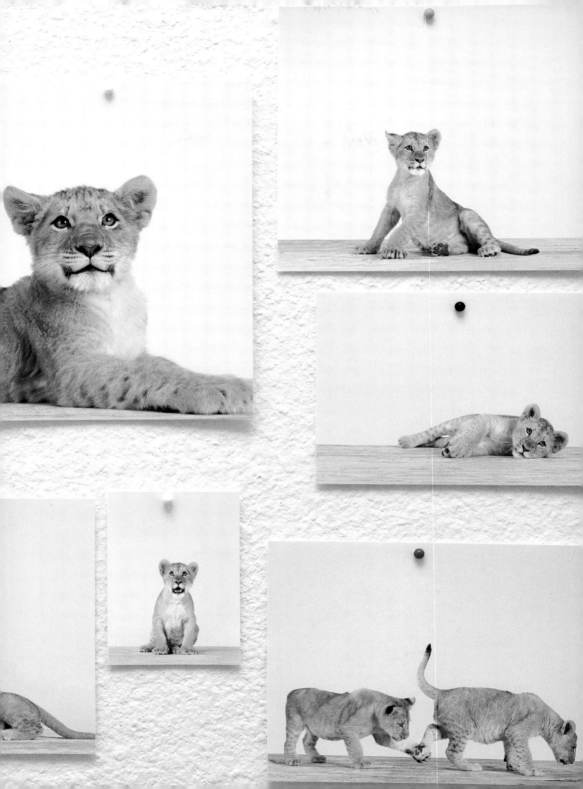

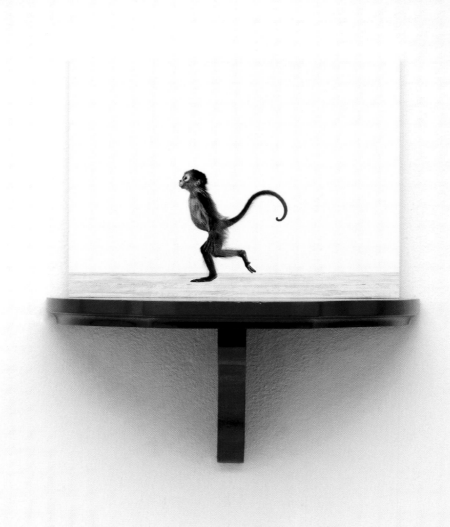

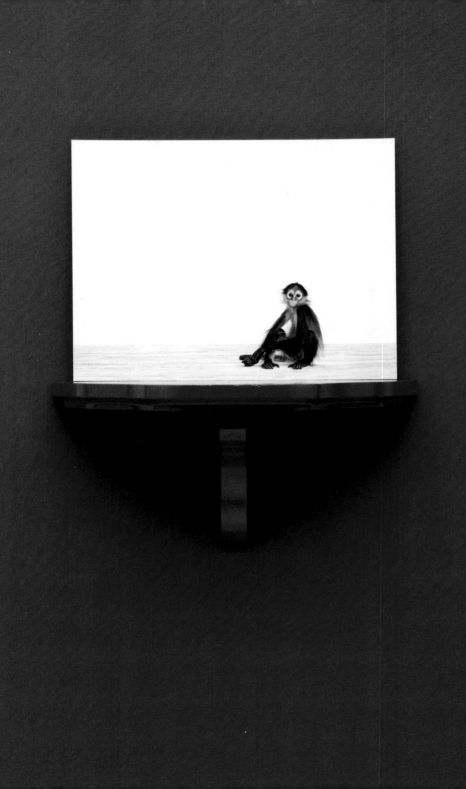

The day is better spent with you

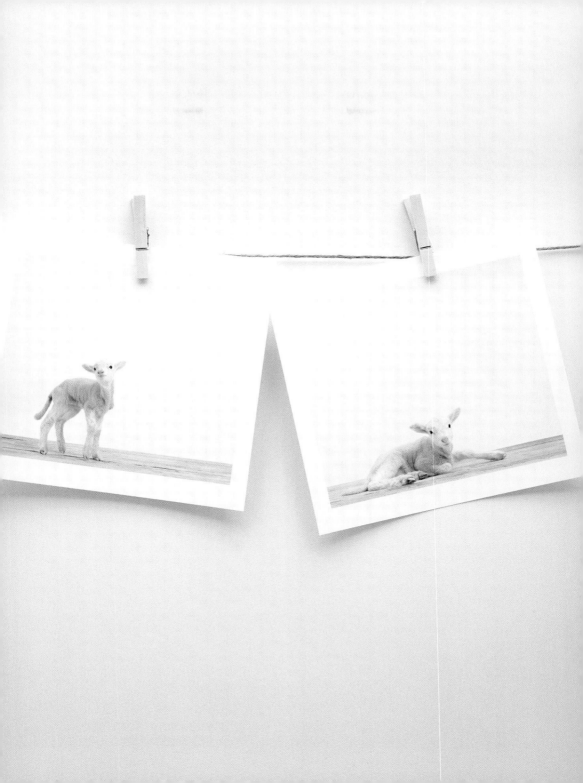

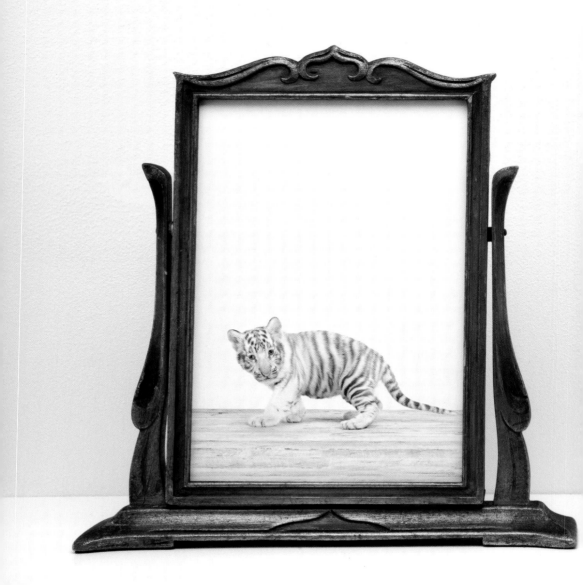

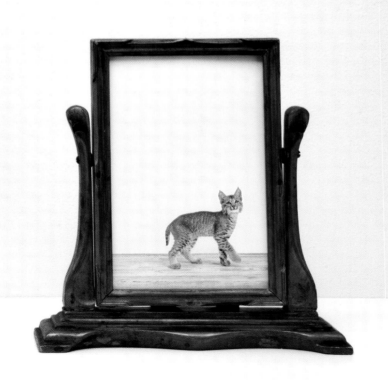

smile

like you have nothing to prove

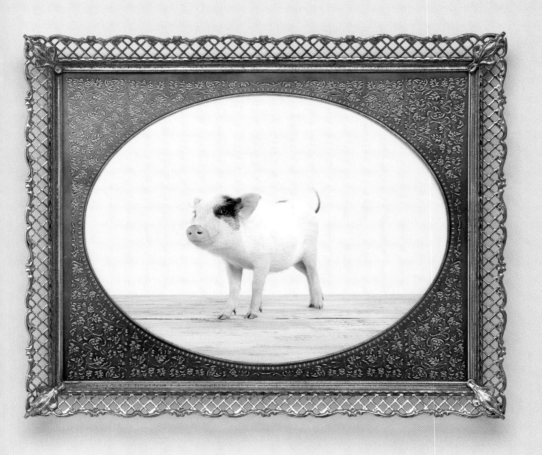

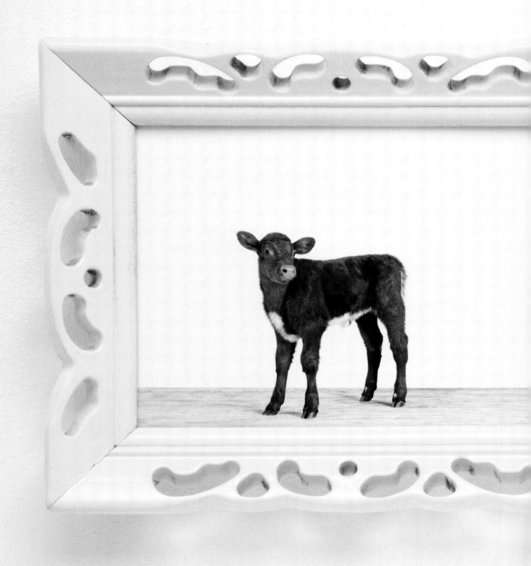

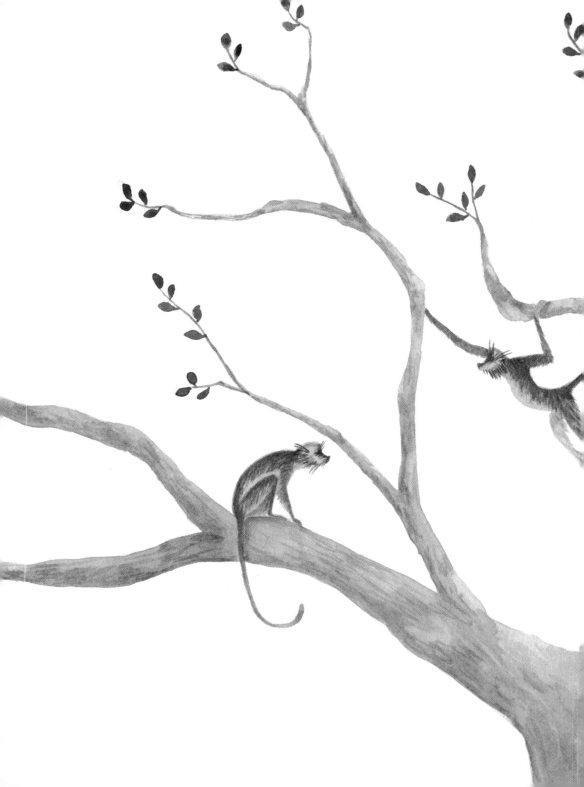

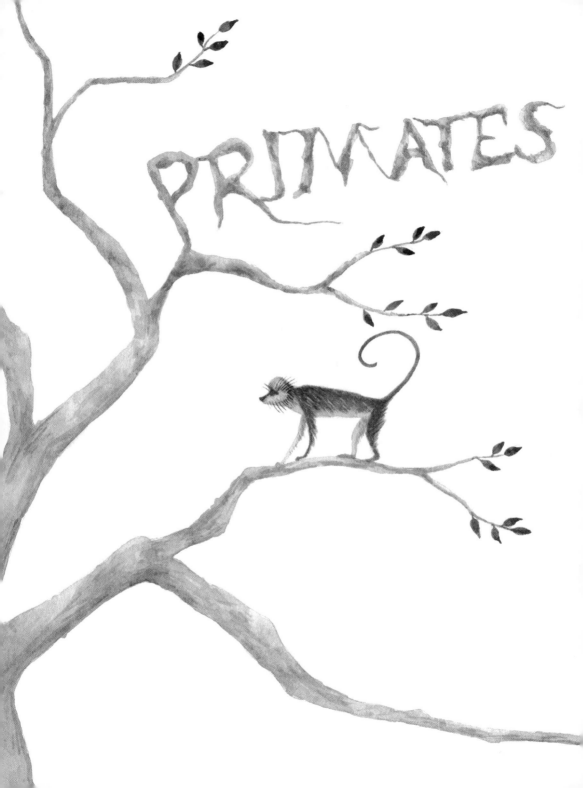

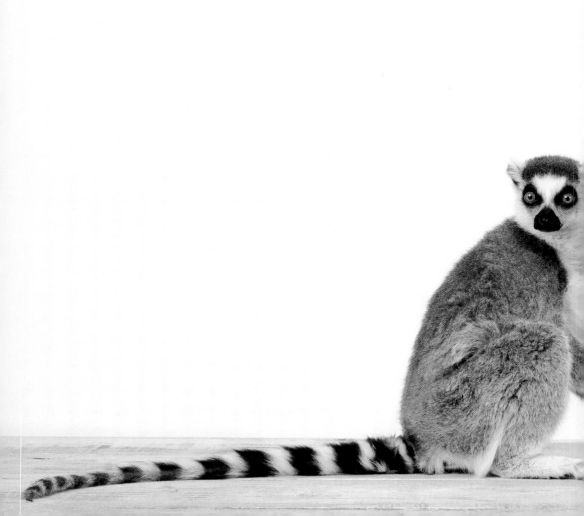

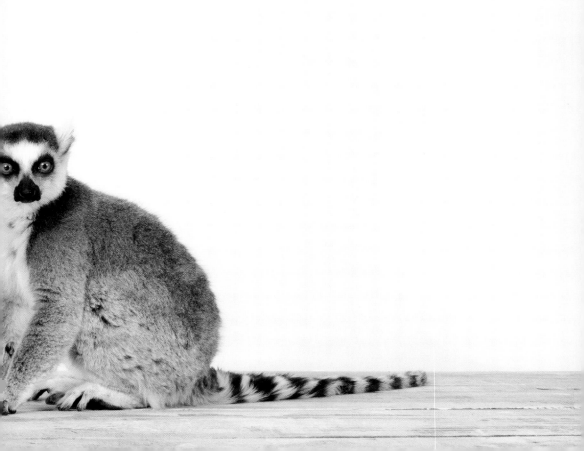

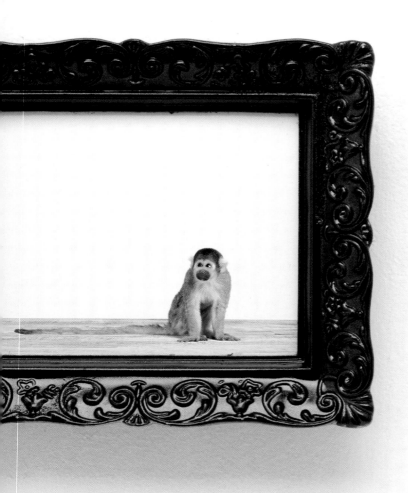

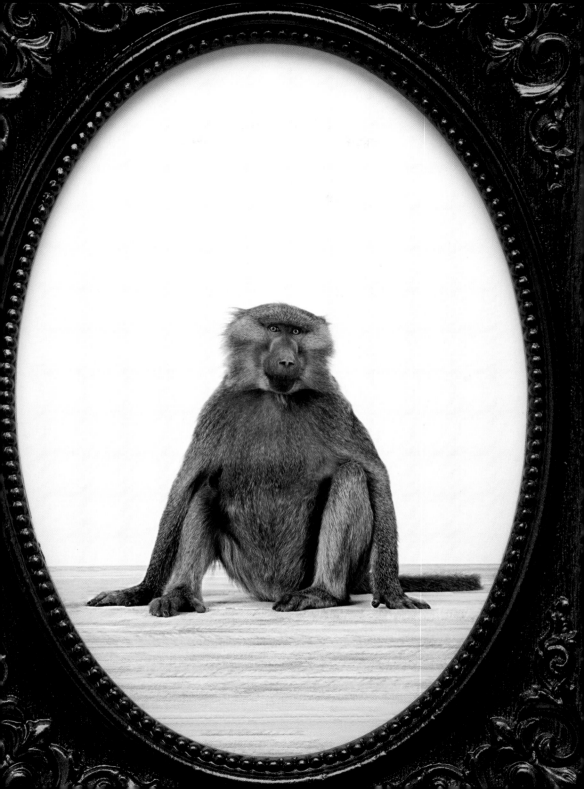

Reptiles

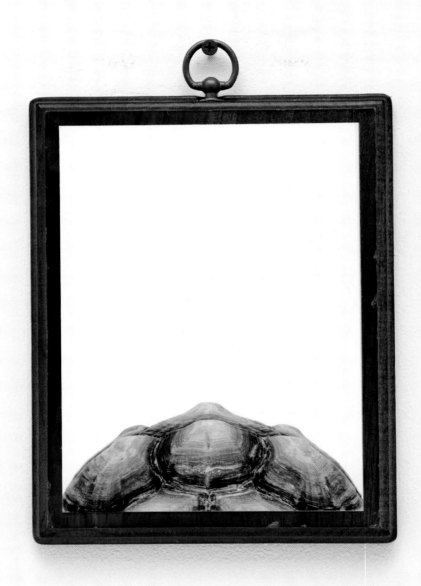

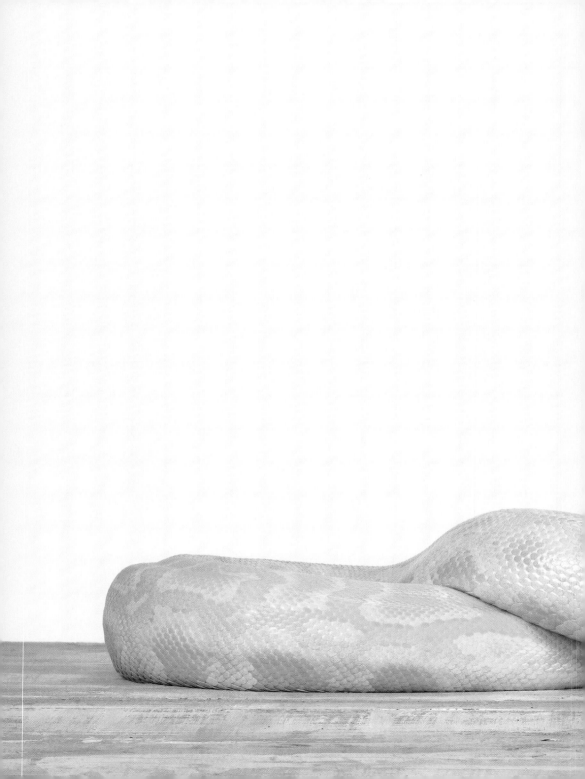

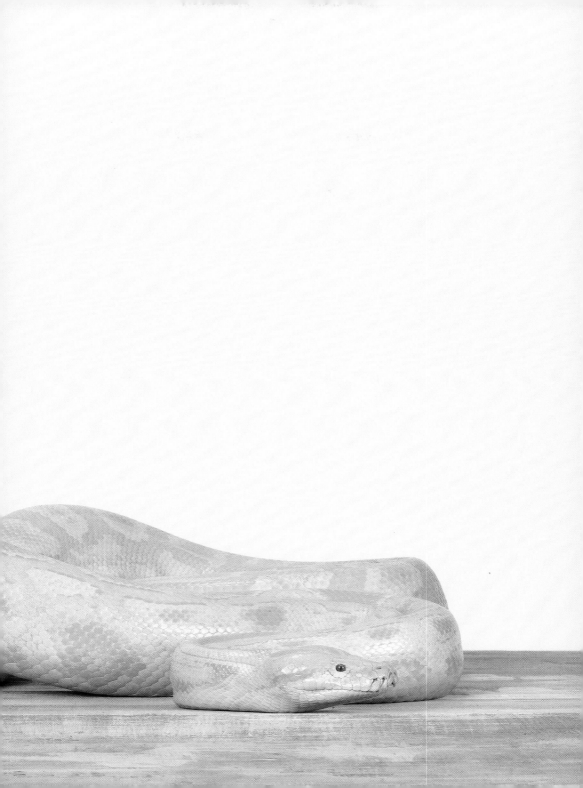

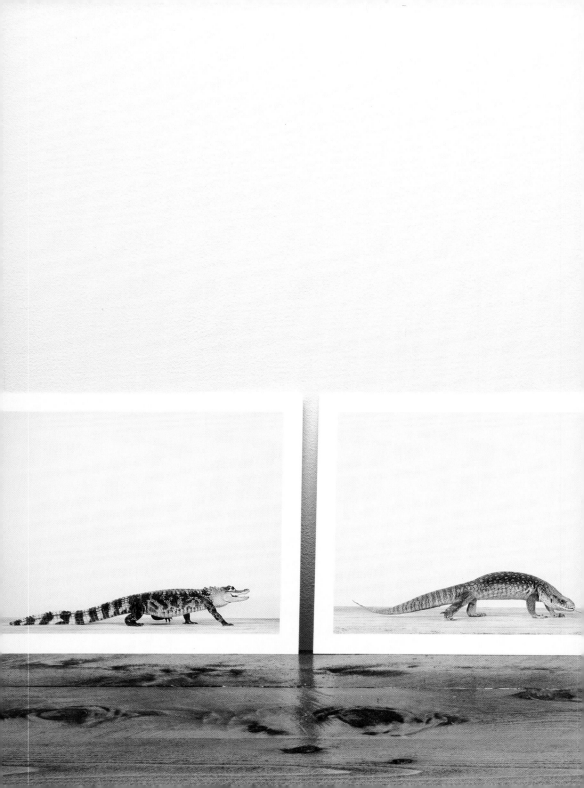

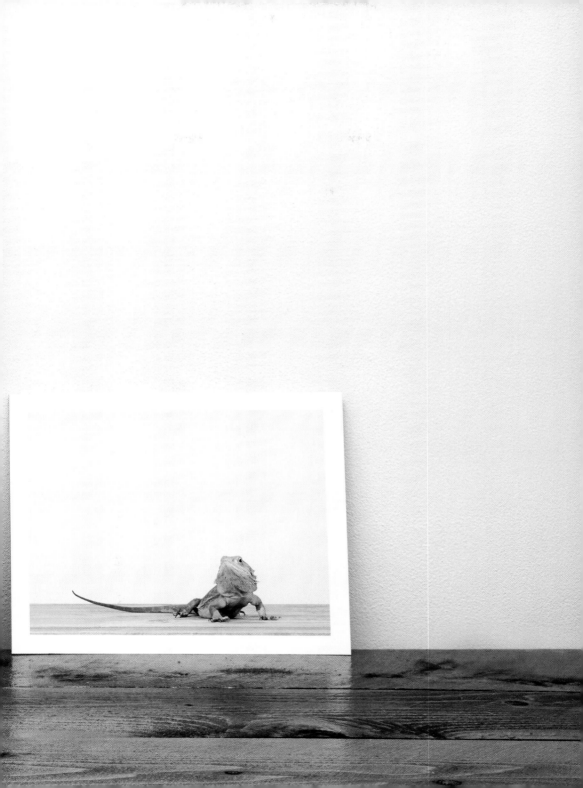

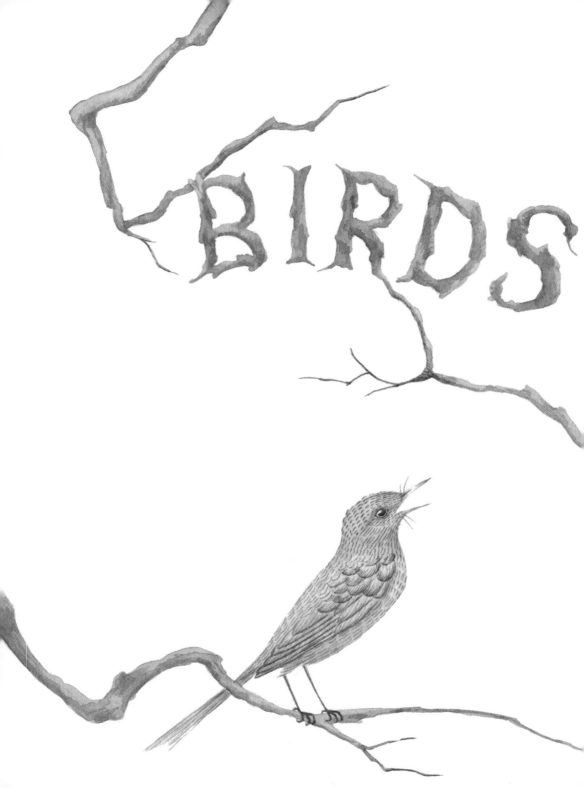

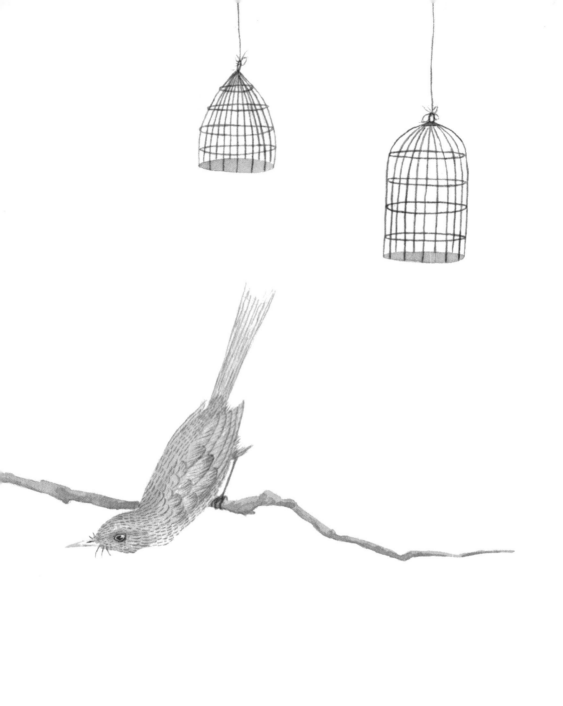

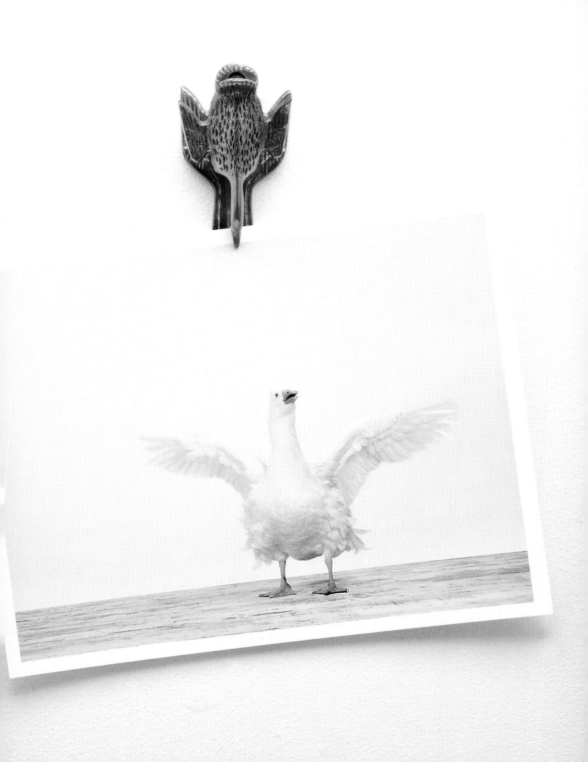

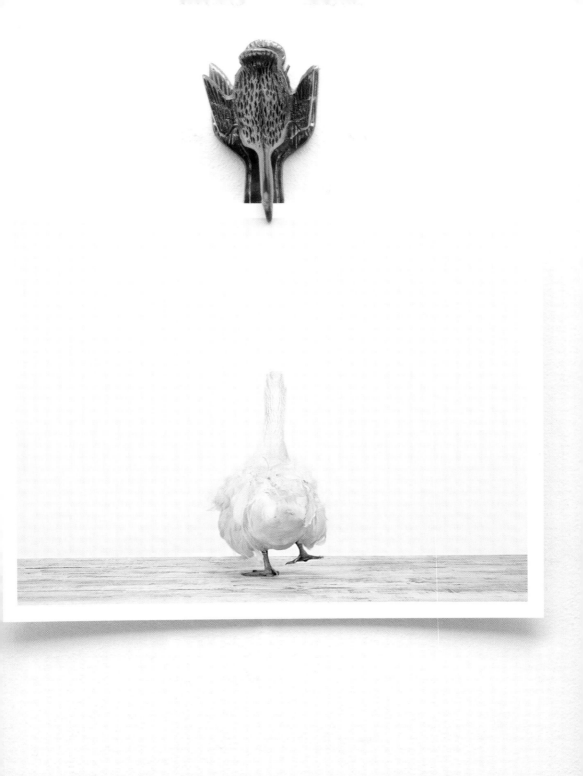

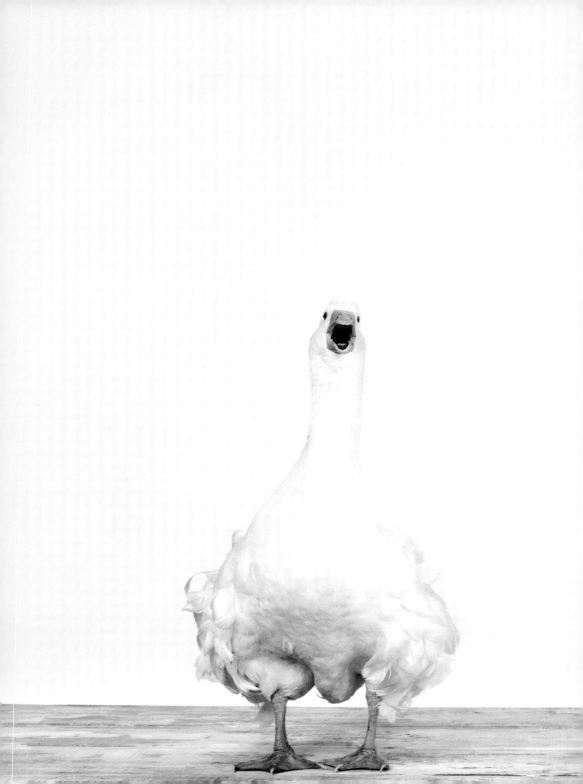

Pretty in Pink

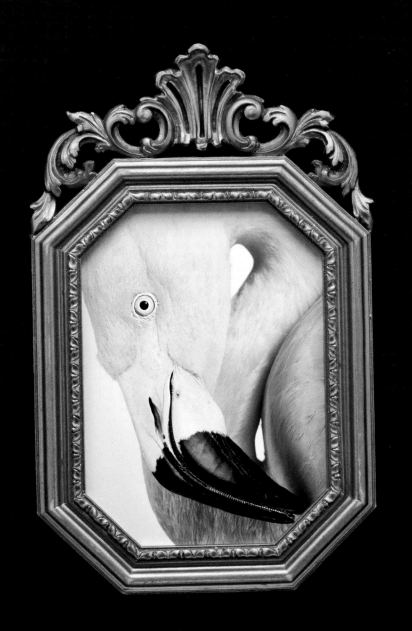

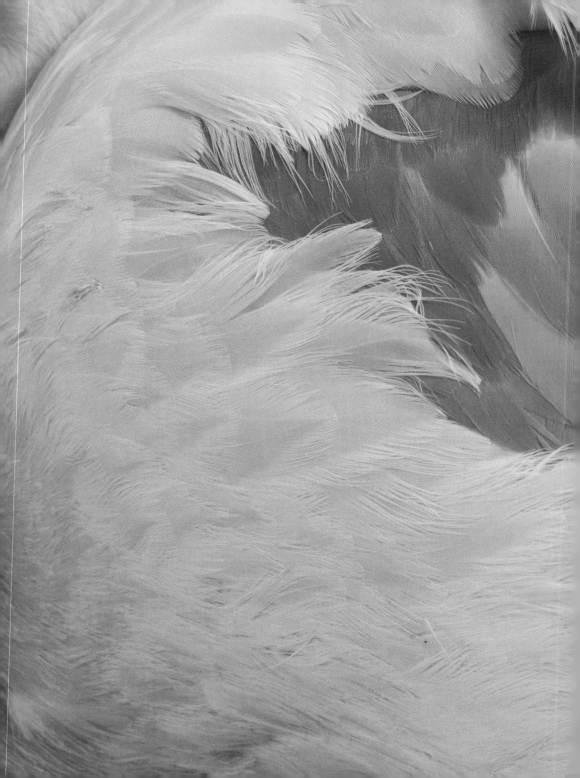

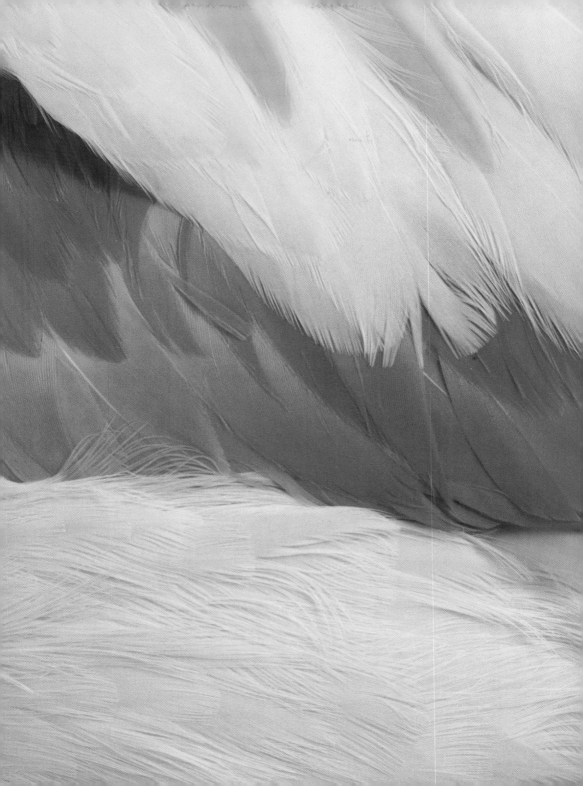

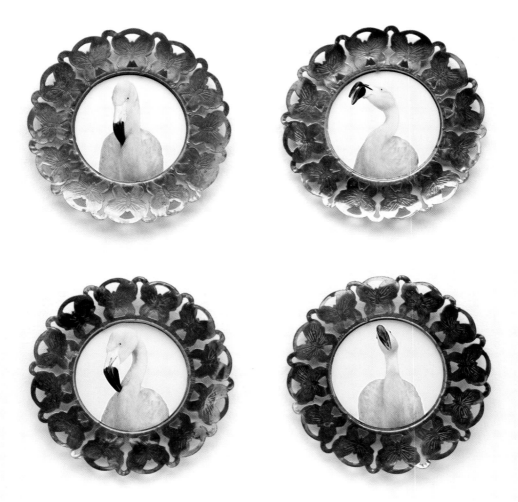

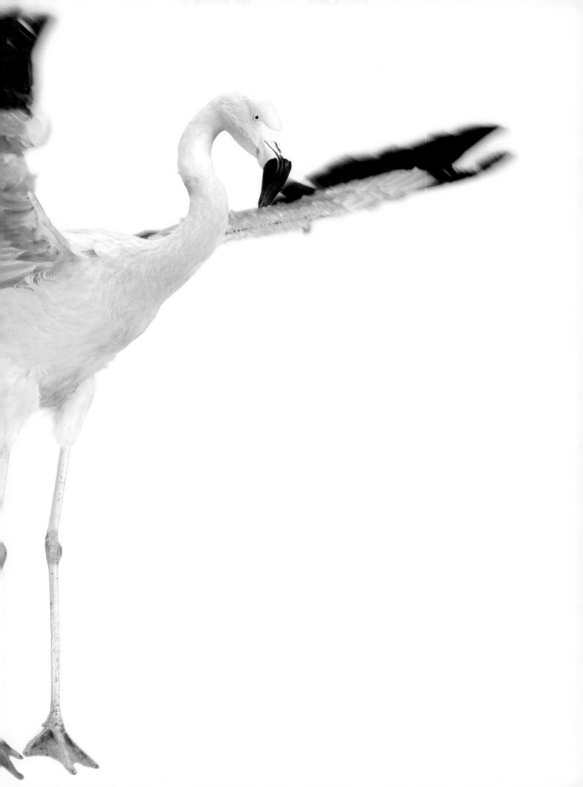

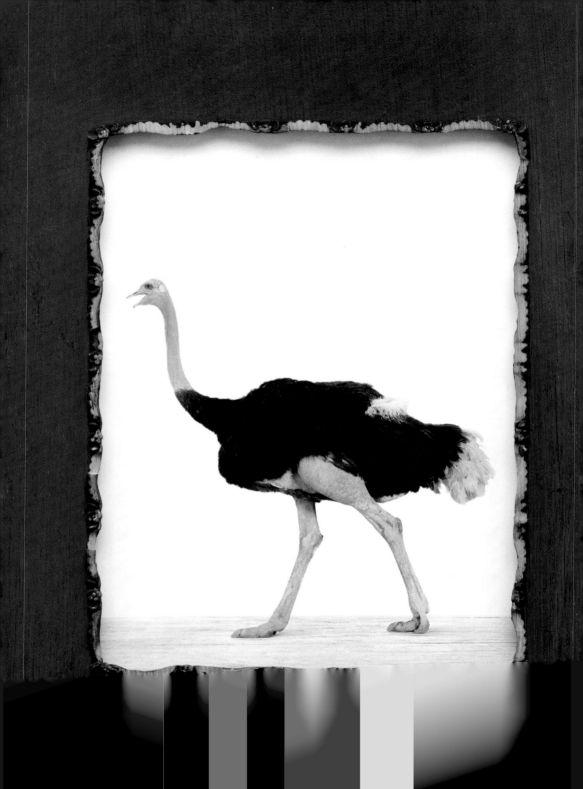

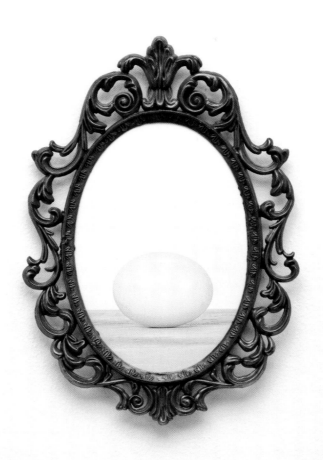

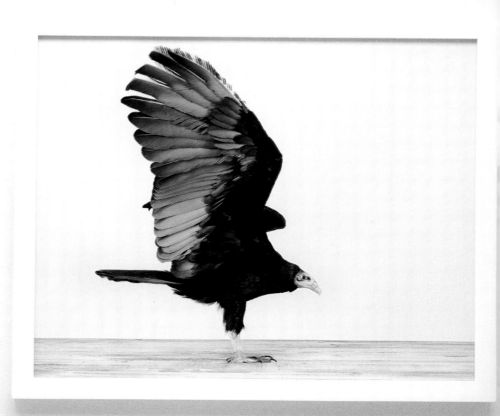

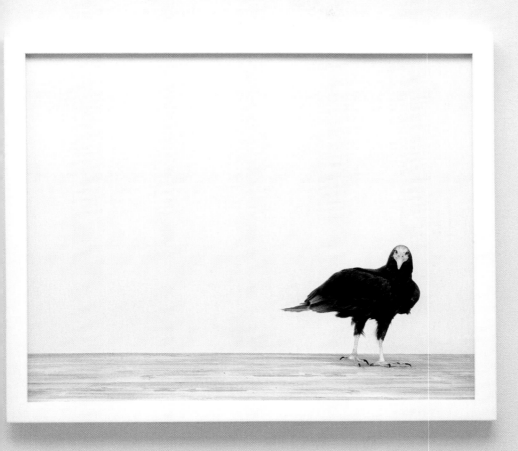

The World
is my
Home

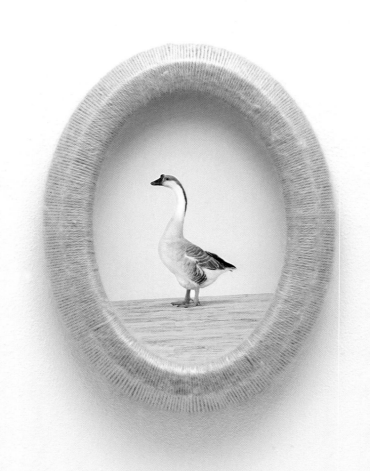

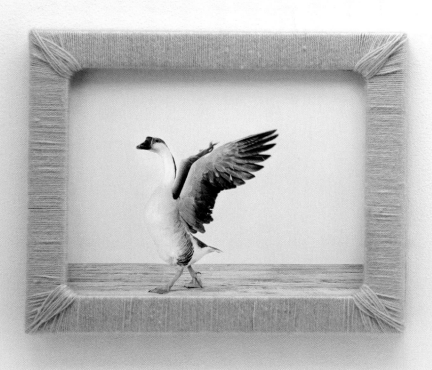

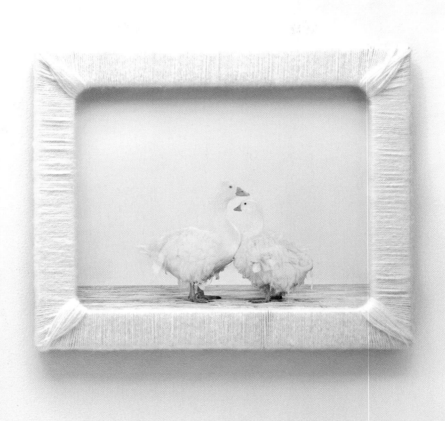

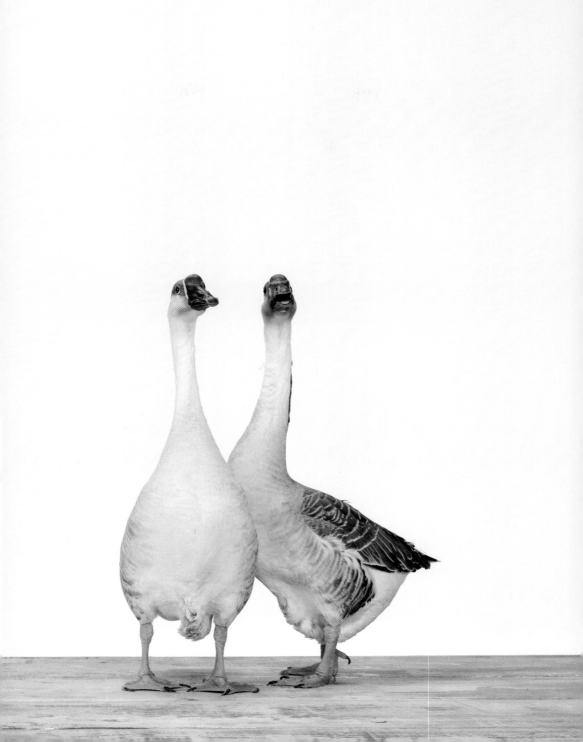

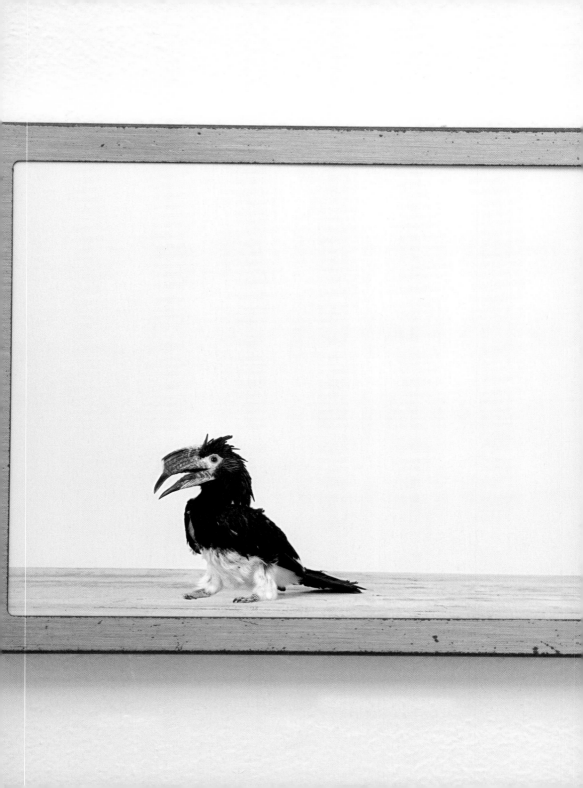

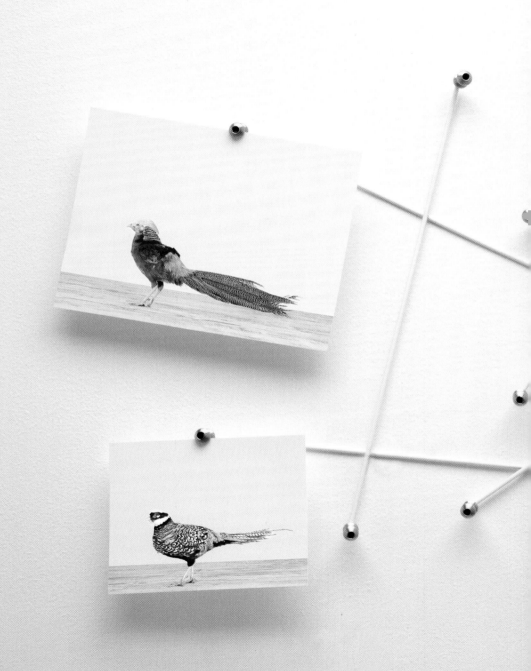

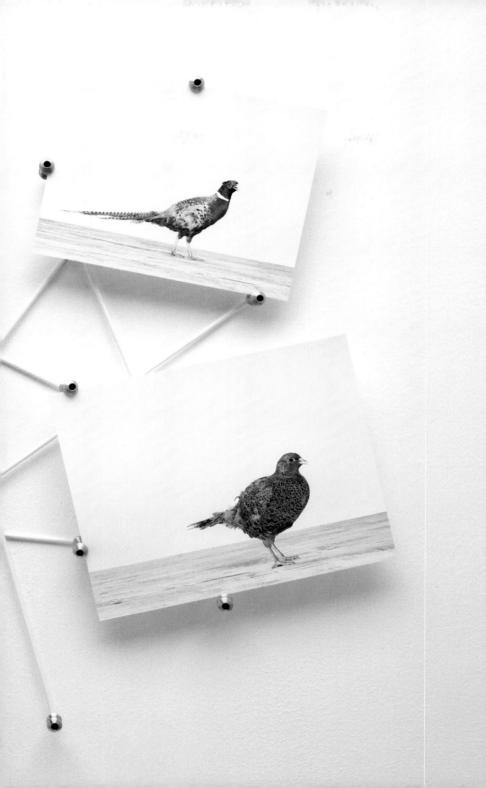

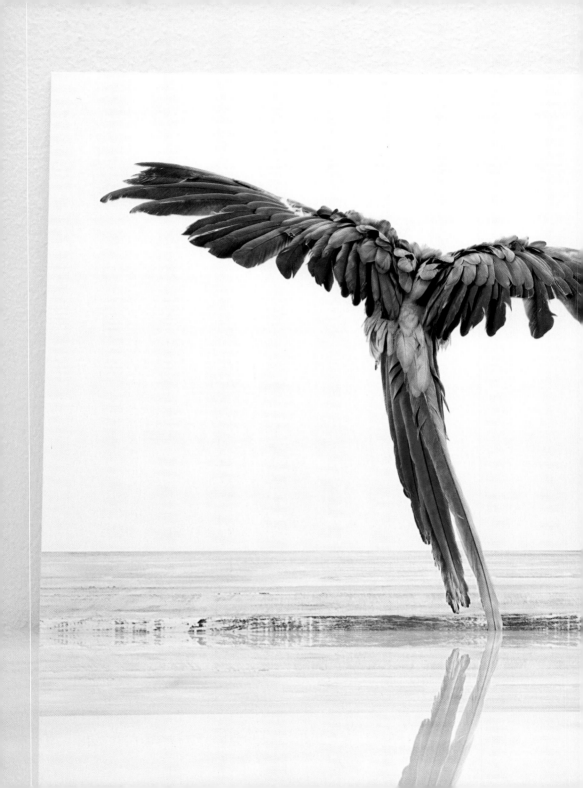

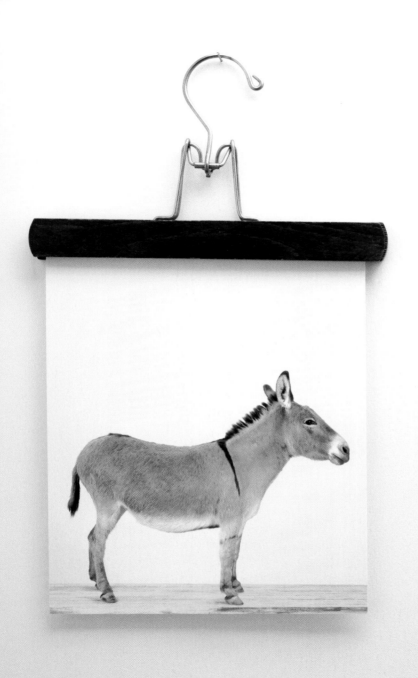

JUST WAITING FOR THE
GRASS
TO TURN
GREEN

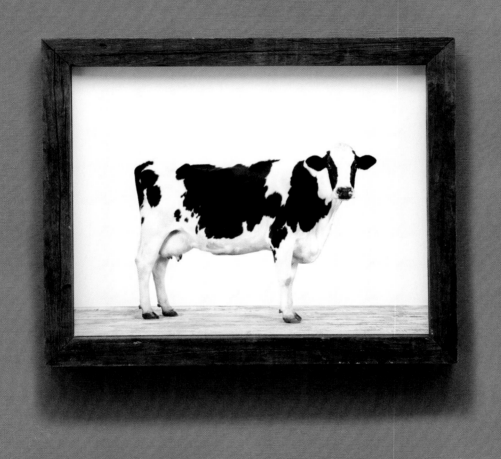

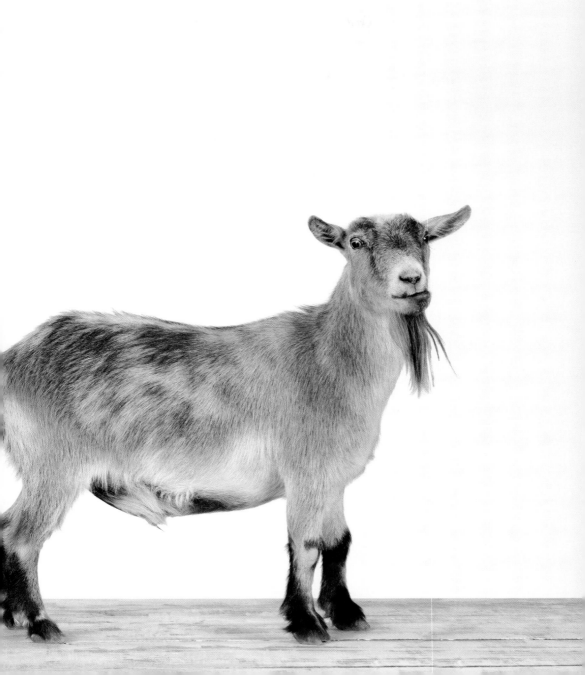

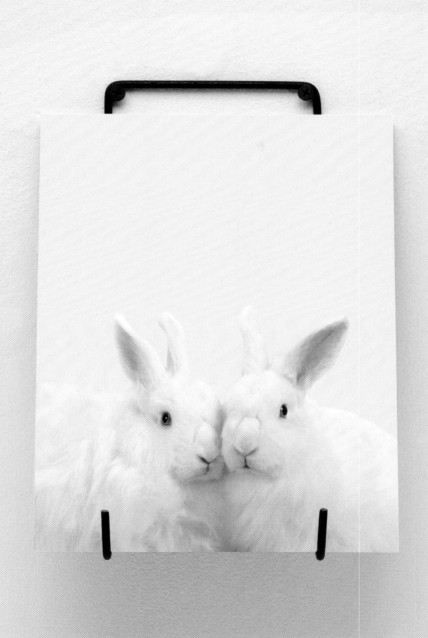

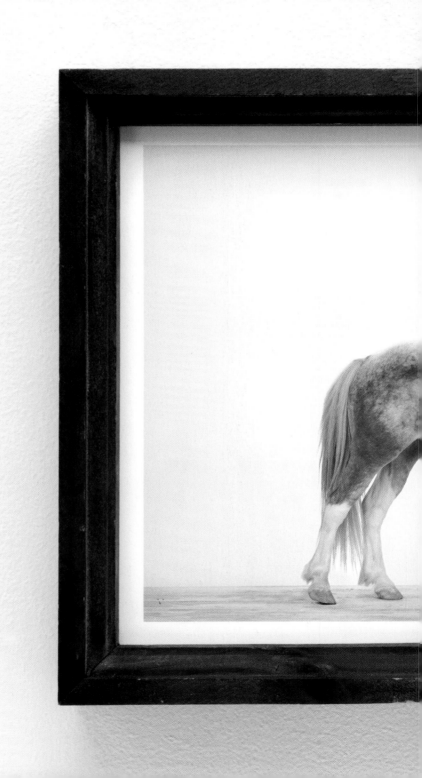

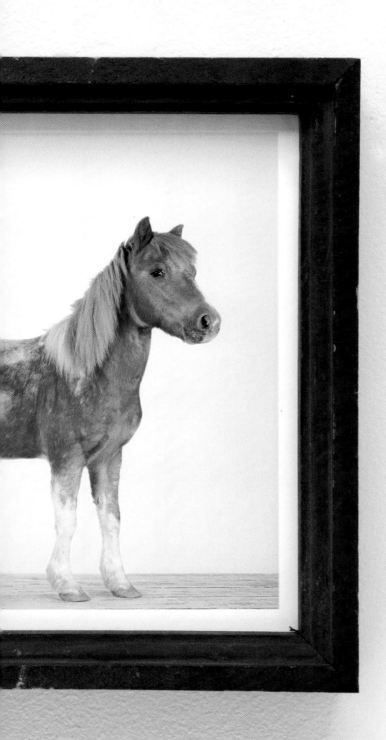

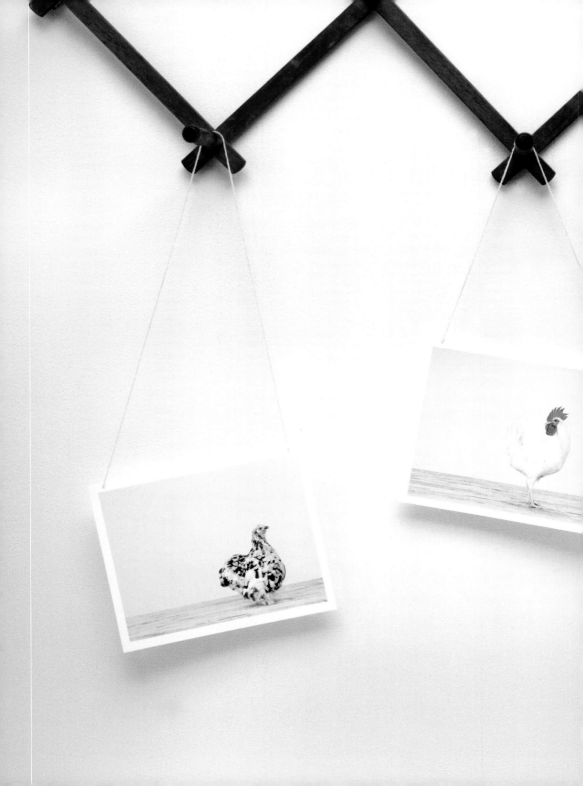

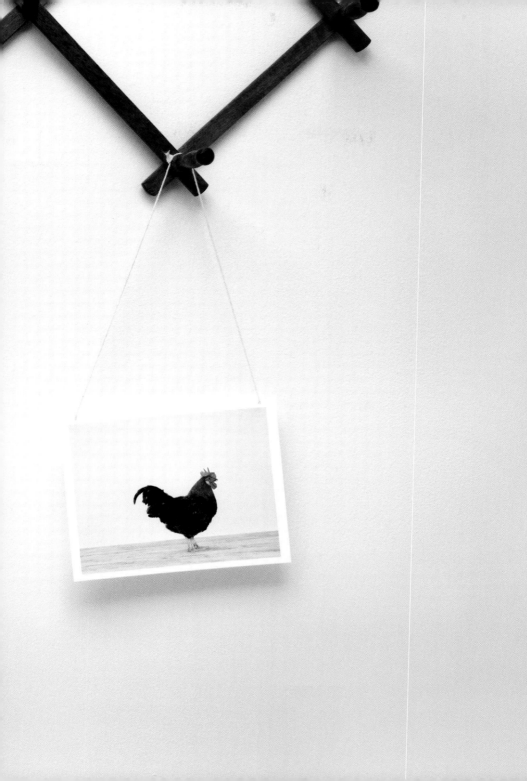

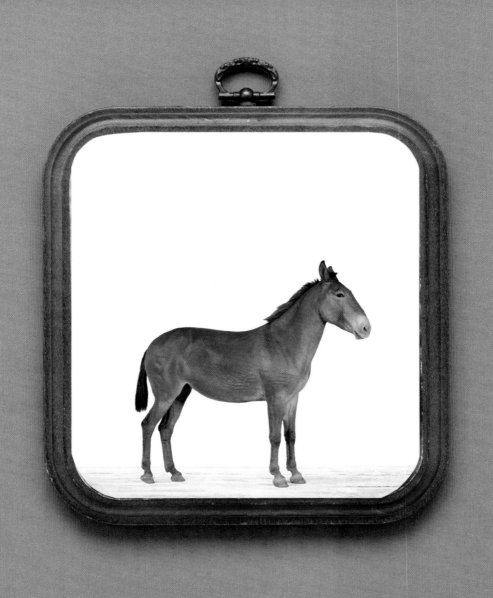

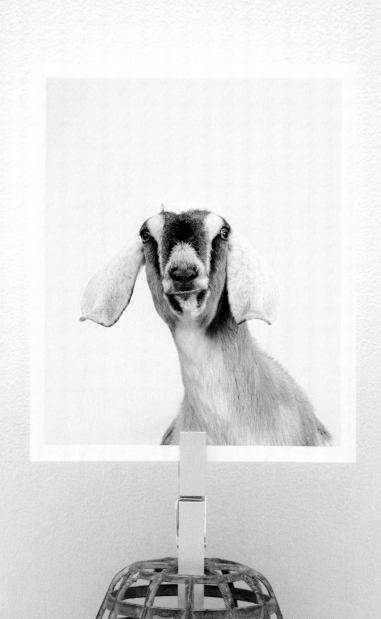

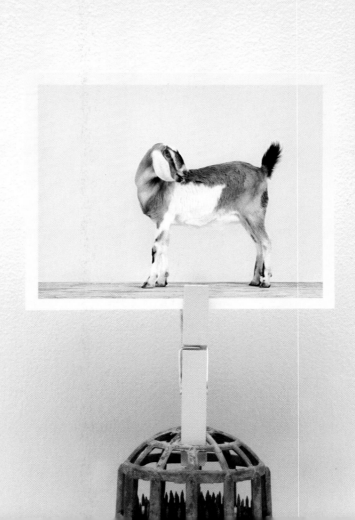

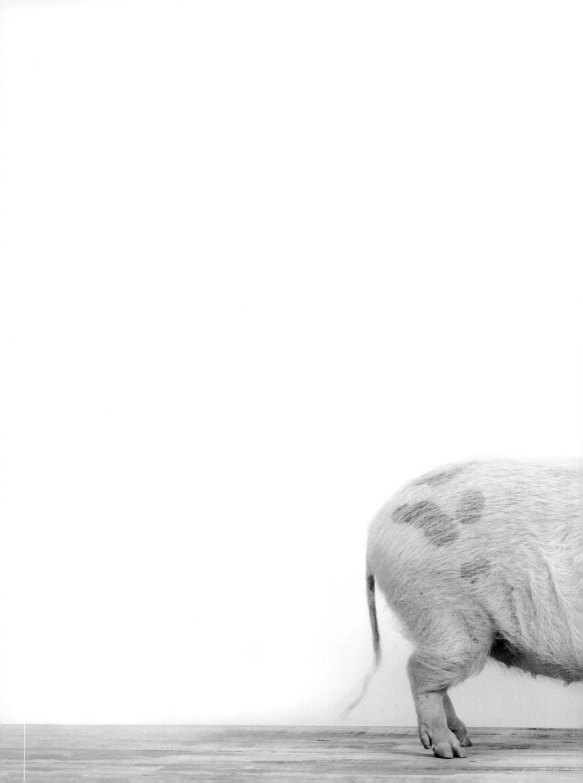

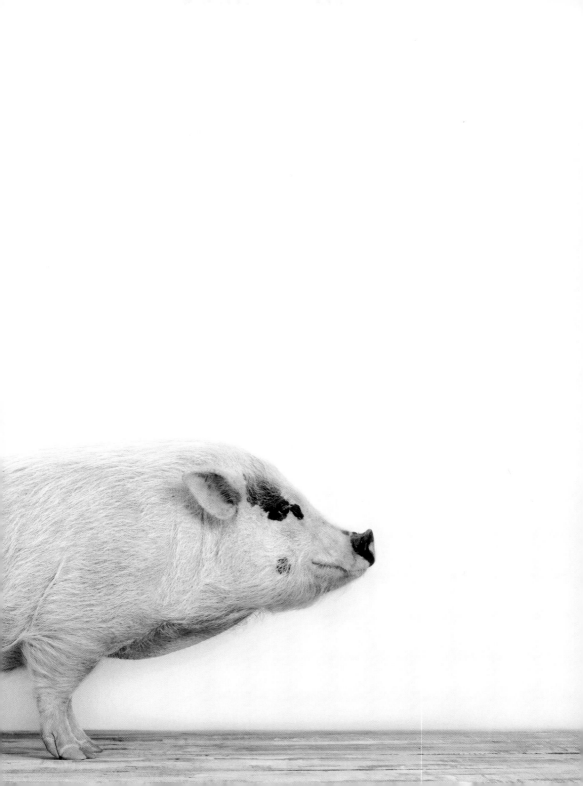

AIN'T
NOBODY
HERE
BUT US
CHICKENS

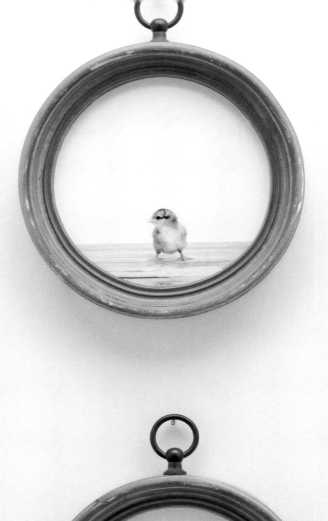
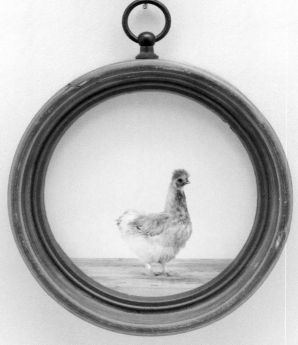

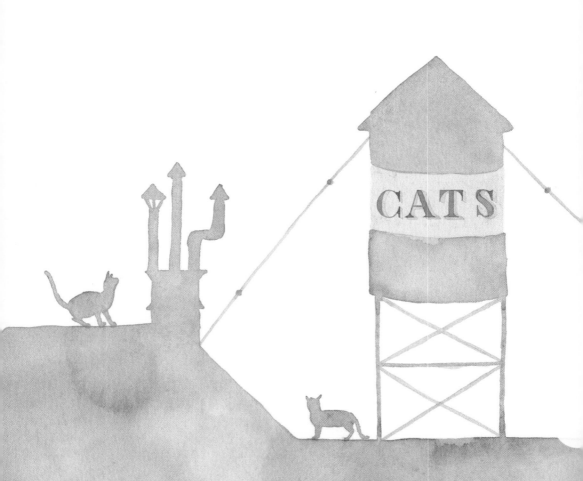

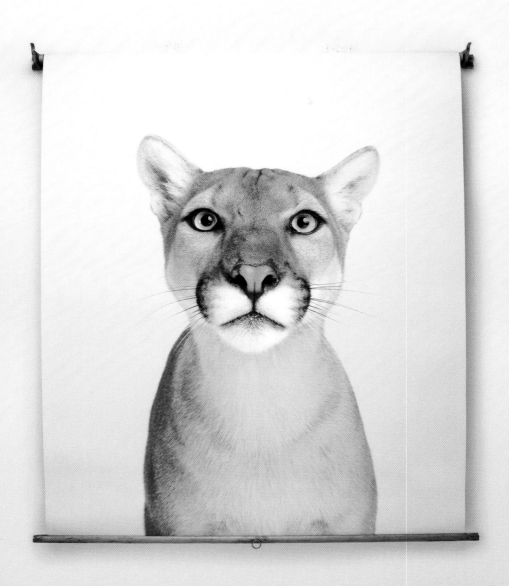

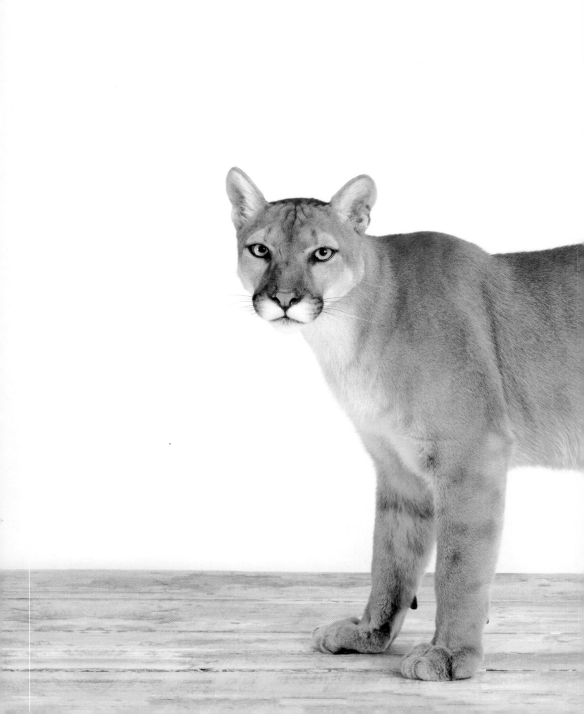

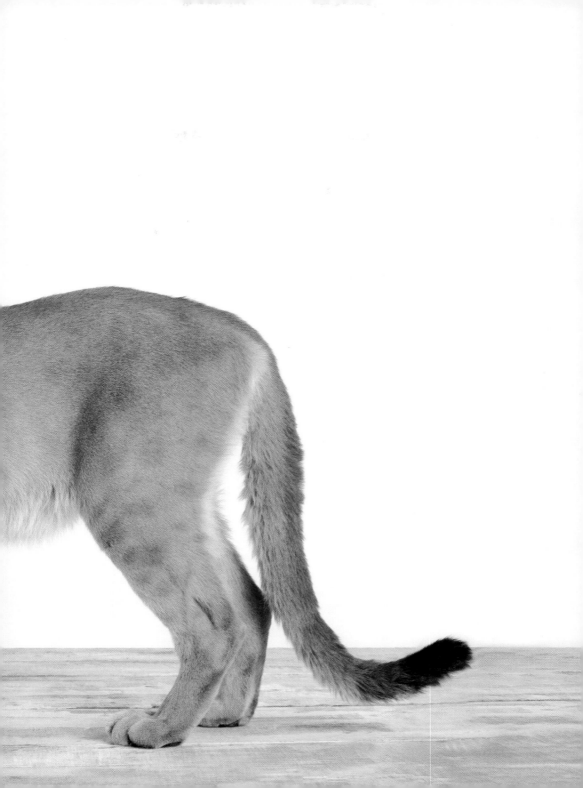

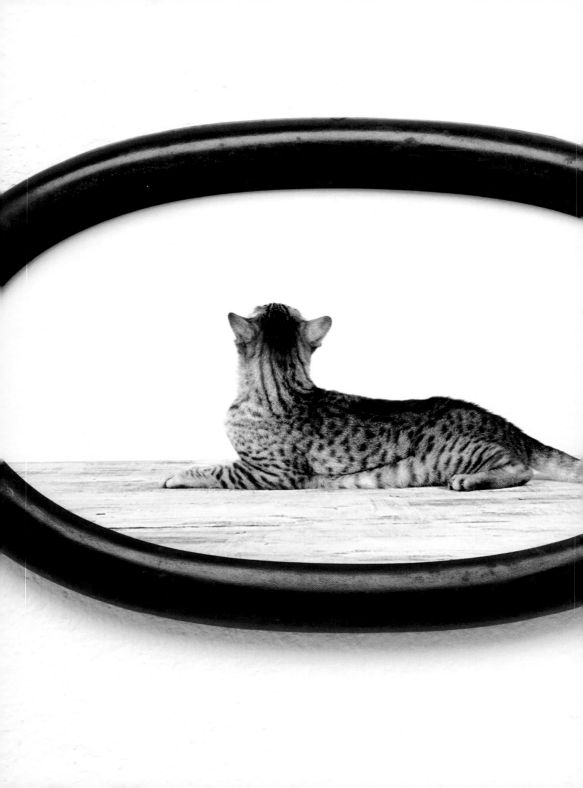

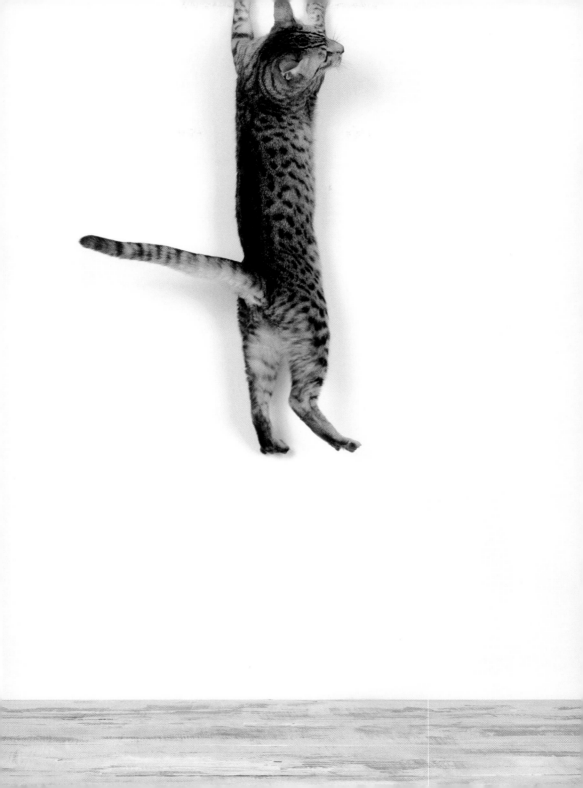

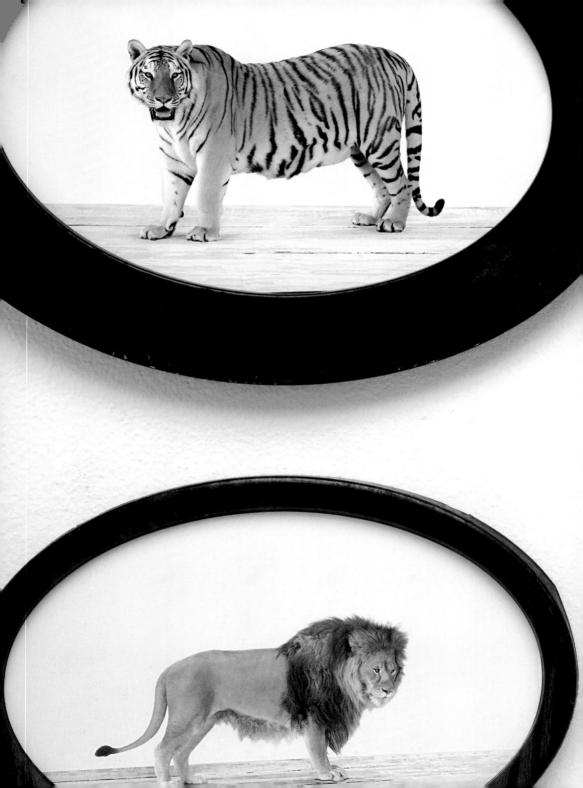

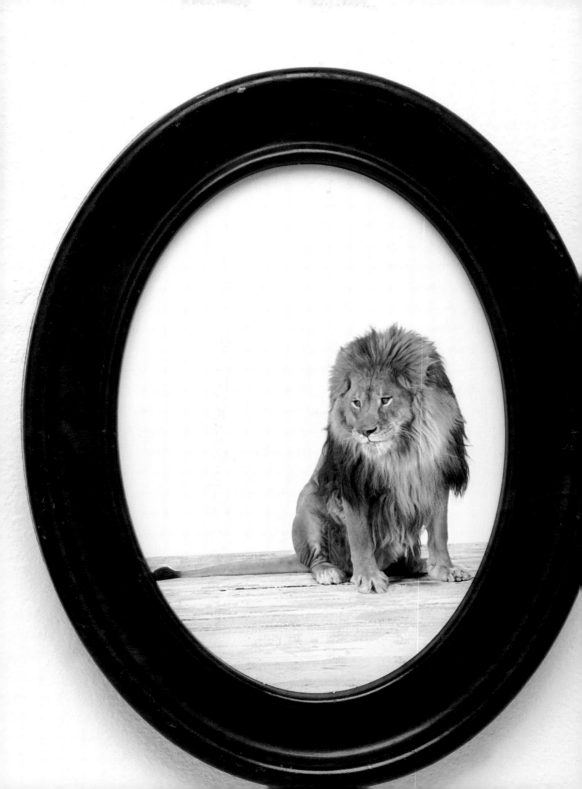

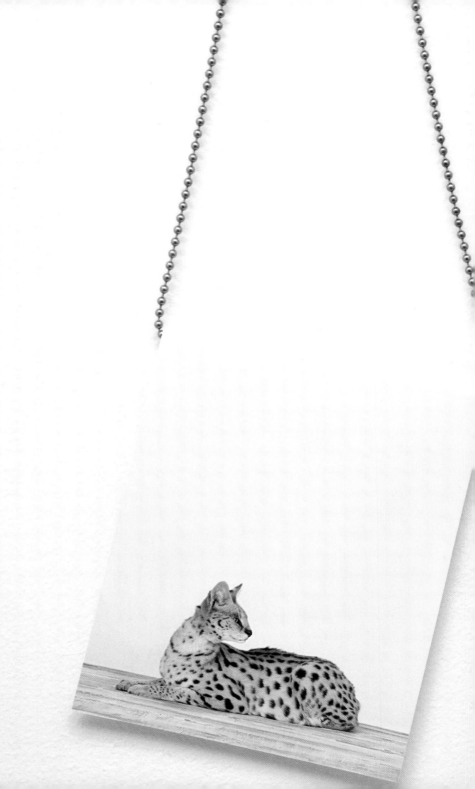

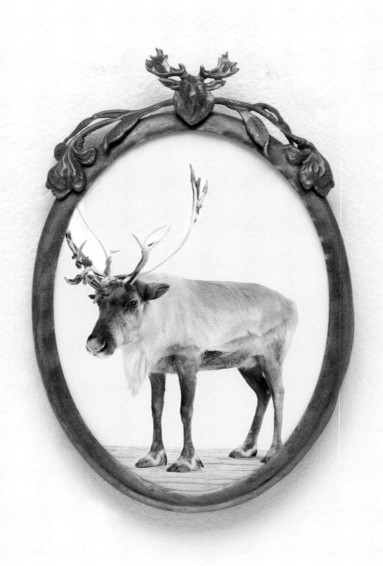

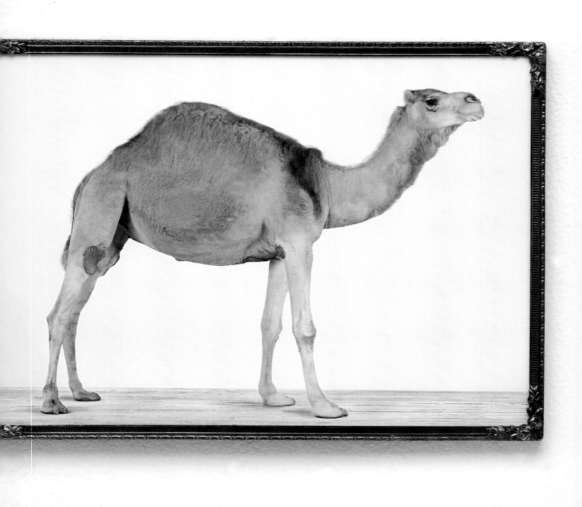

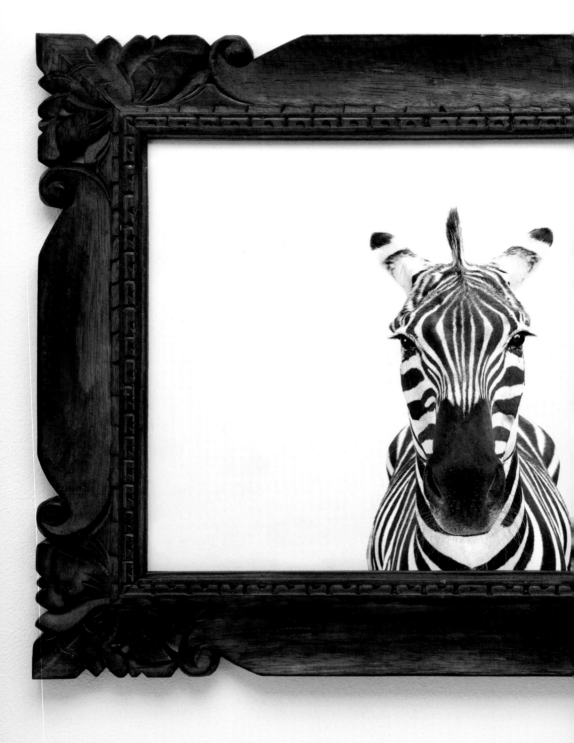

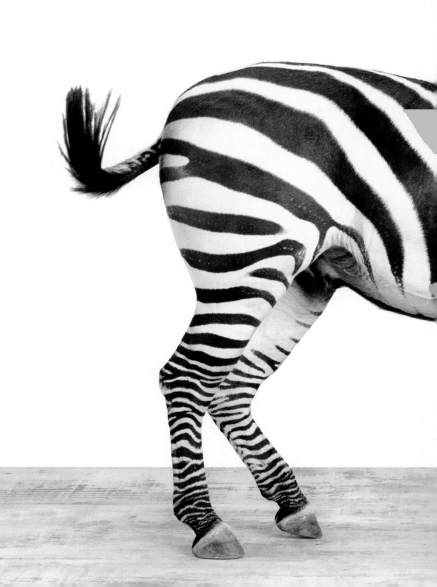

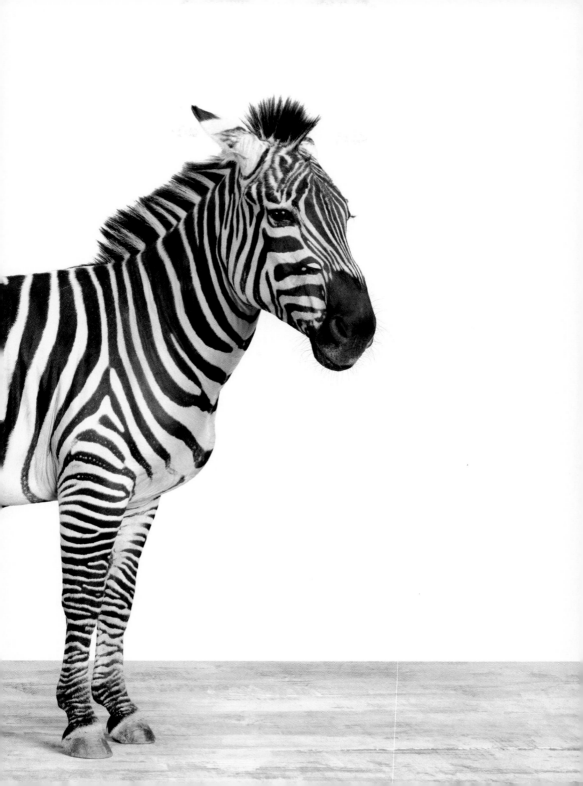

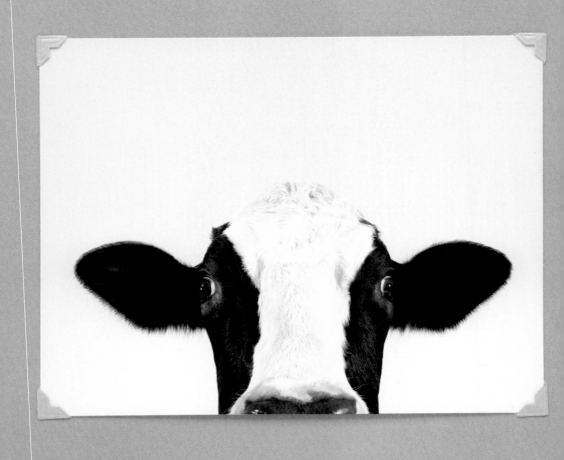

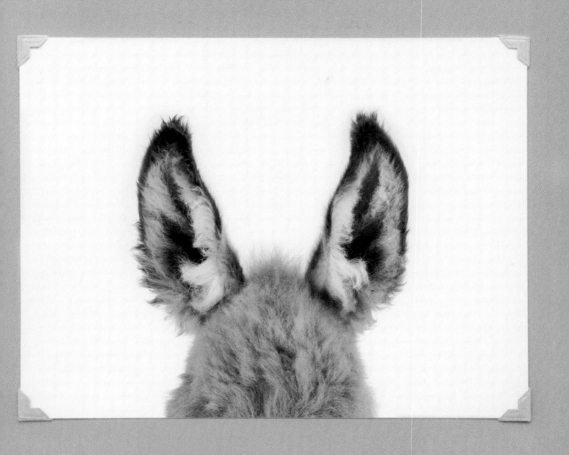

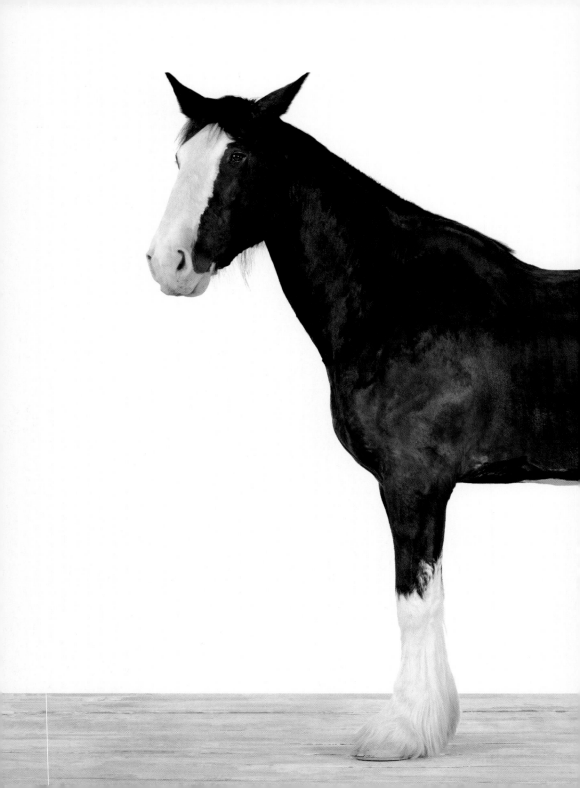

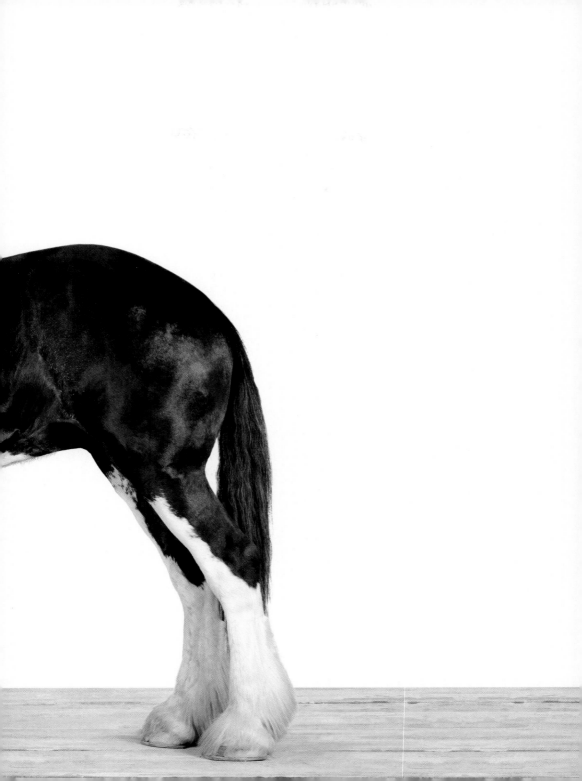

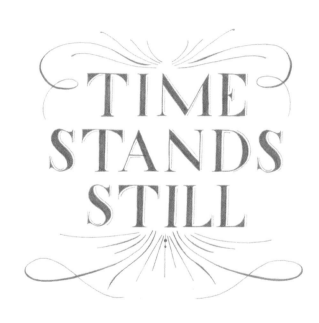

TIME
STANDS
STILL

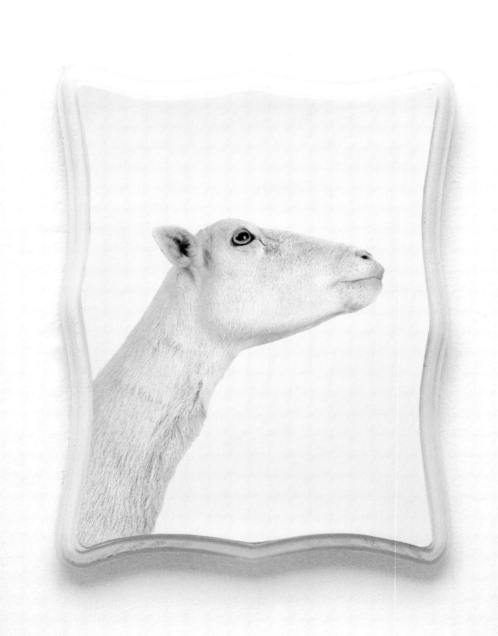

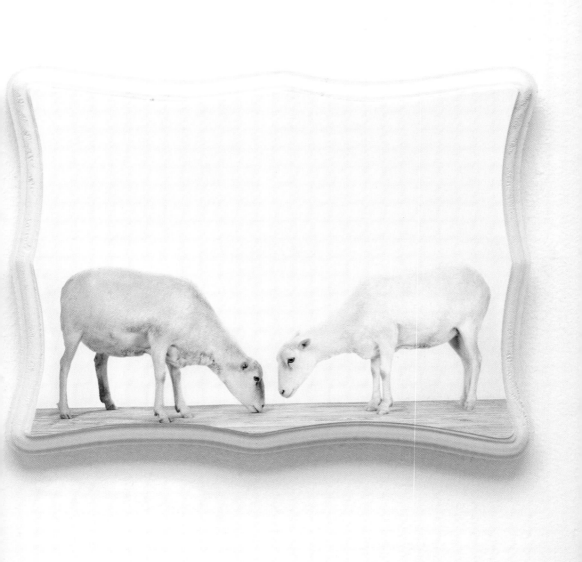

The Animals

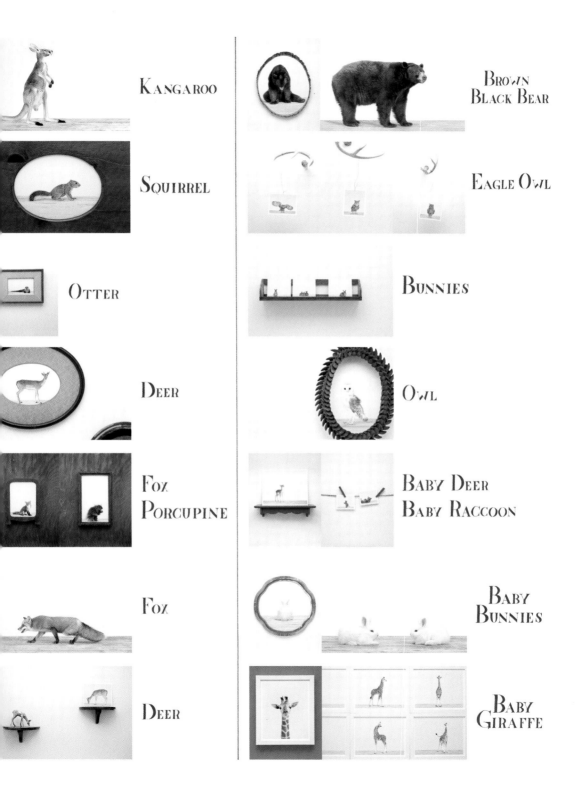

KANGAROO

BROWN
BLACK BEAR

SQUIRREL

EAGLE OWL

OTTER

BUNNIES

DEER

OWL

FOX
PORCUPINE

BABY DEER
BABY RACCOON

FOX

BABY
BUNNIES

DEER

BABY
GIRAFFE

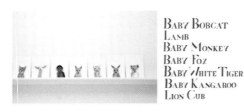

BABY BOBCAT
LAMB
BABY MONKEY
BABY FOX
BABY WHITE TIGER
BABY KANGAROO
LION CUB

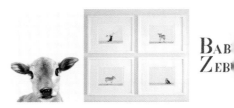

BABY ZEB

BABY GOAT

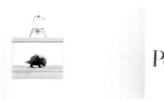

BABY PORCUPINE

BABY DONKEY

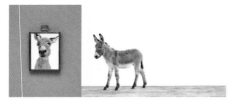

LION CUBS

BABY FOX
BASSET HOUND PUPPY

BABY MONKEY

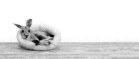

BABY KANGAROO

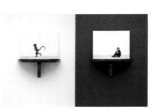

LAMB

BABY CRANE

BABY WHITE TIGER
BABY BOBCAT

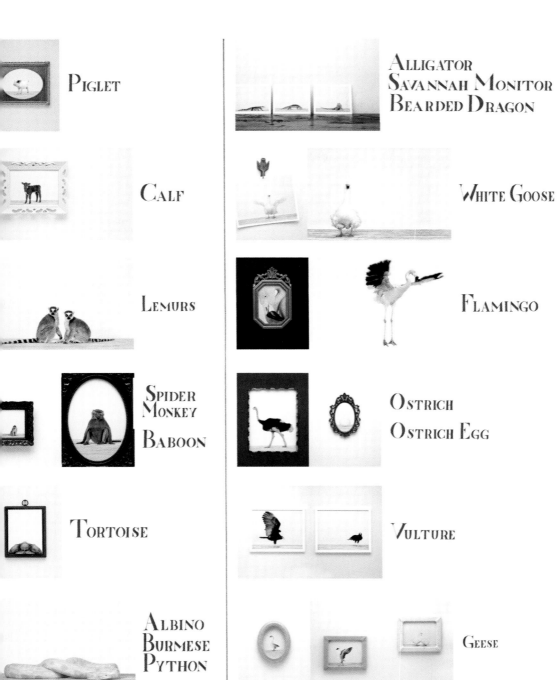

PIGLET

ALLIGATOR
SAVANNAH MONITOR
BEARDED DRAGON

CALF

WHITE GOOSE

LEMURS

FLAMINGO

SPIDER
MONKEY
BABOON

OSTRICH
OSTRICH EGG

TORTOISE

VULTURE

ALBINO
BURMESE
PYTHON

GEESE

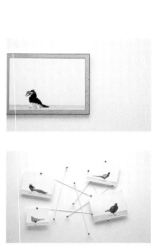 Trumpeter Bird

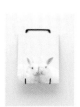 Rabbits

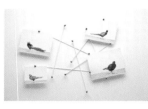 Pheasants

 Pony

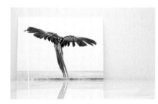 Macaw

 Chicken Roosters

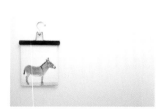 Miniature Donkey

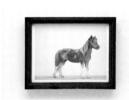 Mule

 Cow

 Nubian Goat

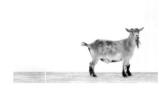 Pygmy Goat

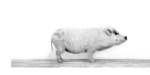 Pig

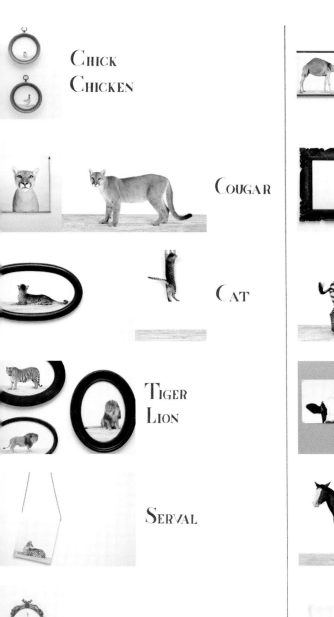

CHICK
CHICKEN

COUGAR

CAT

TIGER
LION

SERVAL

REINDEER

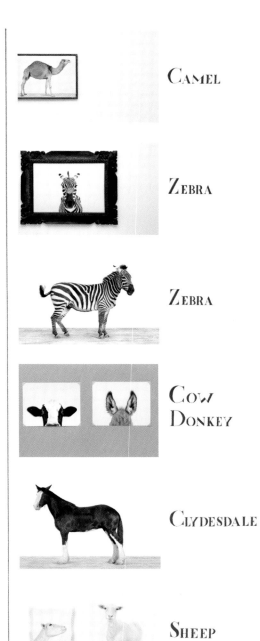

CAMEL

ZEBRA

ZEBRA

COW
DONKEY

CLYDESDALE

SHEEP

Resources

The Animal Prints showcased in this book
are available for purchase through:
The Animal Print Shop
WWW.THEANIMALPRINTSHOP.COM

Illustrations and Lettering:
Julianna Swaney
WWW.OHMYCAVALIER.COM

White Gallery Frames:
West Elm
WWW.WESTELM.COM

Yarn Frames (Gray Goose):
Kyle Schuneman
WWW.LIVEWELLDESIGNS.COM

Antlers (Eagle Owl):
Antler&Co
WWW.ANTLERANDCO.COM

Vintage Frames:
Thrift Stores
WWW.ETSY.COM
WWW.EBAY.COM

Acknowledgments

I would like to extend my deepest gratitude to my amazing husband, Spencer Starr (I'm not easy to live with when I'm under book deadlines!), my editor, Cassie Jones (a true collaborative spirit), the talented and lovely Julianna Swaney (a total dream to work with), and my literary agent, Betsy Amster.

Also Joe Starr, Ann Livedalen, Lisa Lucas, Dara Siegel, Therese Newgard, Kim Lewis, Lorie Pagnozzi, Karen Lumley, Brian Toro, Dave Schafer, and all the dedicated animal handlers who lovingly care for these amazing animals as their own and ensured their welfare while being photographed.

A giant thank-you to the first person who blogged this series, Nichole Robertson (www.littlebrownpen.blogspot.com).

Also Joanna Goddard (www.joannagoddard.blogspot.com), Tina Roth Eisenberg (www.swiss-miss.com), Victoria Smith (www.sfgirlbybay.com), and all the other generous and countless blogs that have shared my work, along with everyone who has purchased prints.

You've all helped to make this book happen. You've helped me support organizations dedicated to animal rescue, educational programs, and nurturing wildlife. I humbly thank each and every one of you.

Melding her passion for photography with her love of animals, Sharon Montrose's definitive photographic style has made her one of the most sought-after commercial photographers specializing in animals. In addition to ten published photography books to her credit, Sharon shoots for some of the world's foremost pet industry brands. Her animal series photographs (featured in this book) are part of numerous public and private collections and have been awarded recognition by Communication Arts, Photo District News, The Art of Photography, hey, hot shot!, and the International Photography Awards. She lives in Los Angeles with her husband and two dogs. WWW.SHARONMONTROSE.COM

Julianna Swaney was born in Michigan and grew up playing outside with her dogs and cats, going on family vacations to historical sites, and going to antique stores, all of which continue to be an influence on her work. She attended Maine College of Art and got her BFA in 2005. She now makes a living from her artwork in Portland, Oregon. WWW.OHMYCAVALIER.COM

HarperCollins books may be purchased for educational, business, or sales promotional use. For information please write: Special Markets Department, HarperCollins Publishers, 10 East 53rd Street, New York, NY 10022.

First edition

Designed by Sharon Montrose
Illustrated by Julianna Swaney

ISBN 978-0-06-204920-9

11 12 13 14 15 [RRD] 10 9 8 7 6 5 4 3 2